JEU DE PAUME TEL AVIV MUSEUM OF ART

MICHAL ROVNER

FIELDS

STEIDL

24

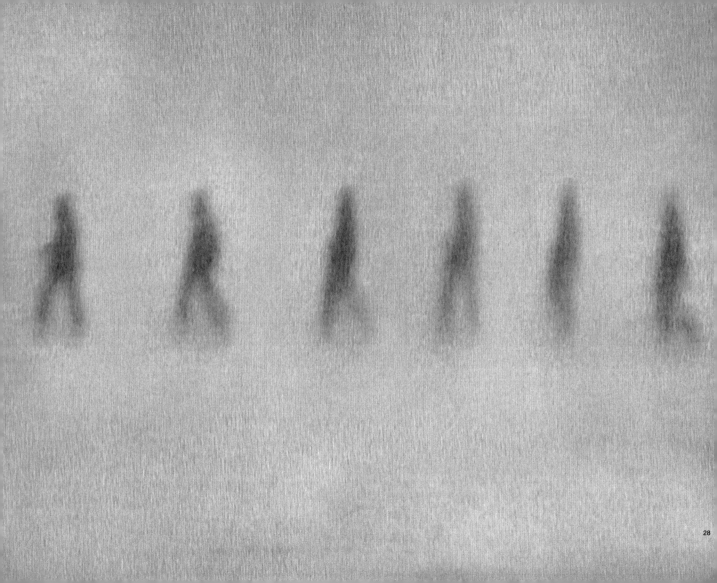

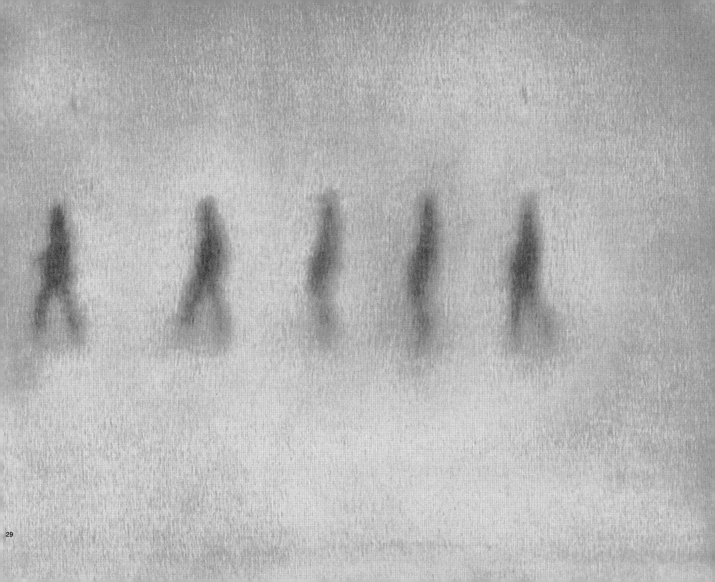

31

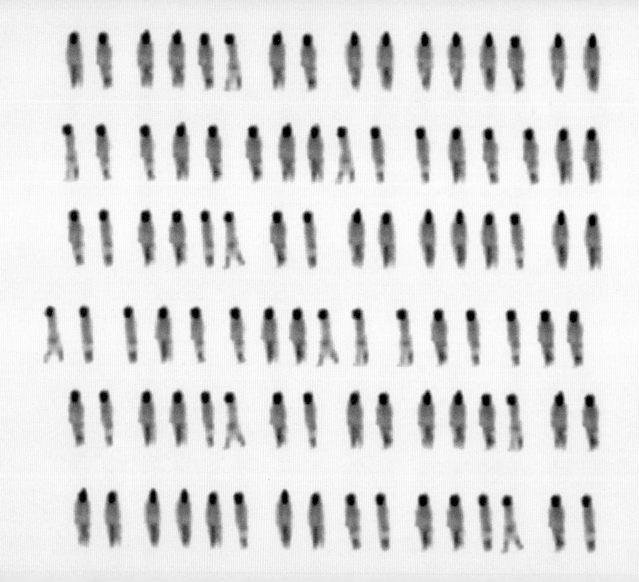

35

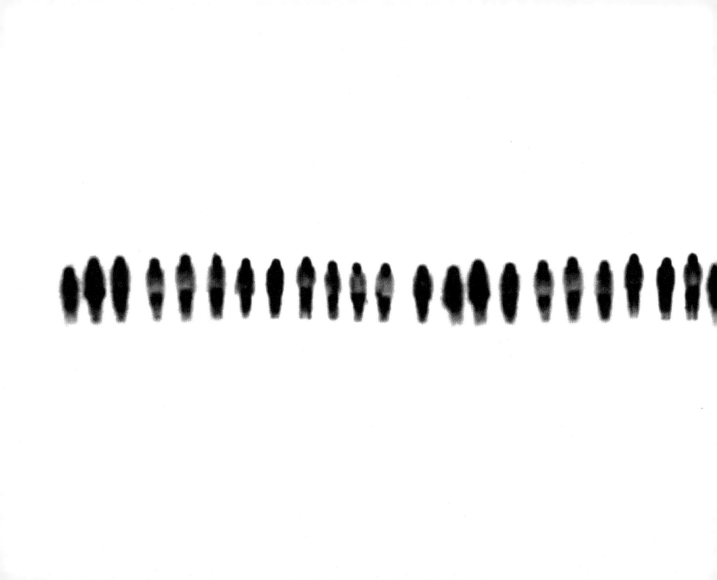

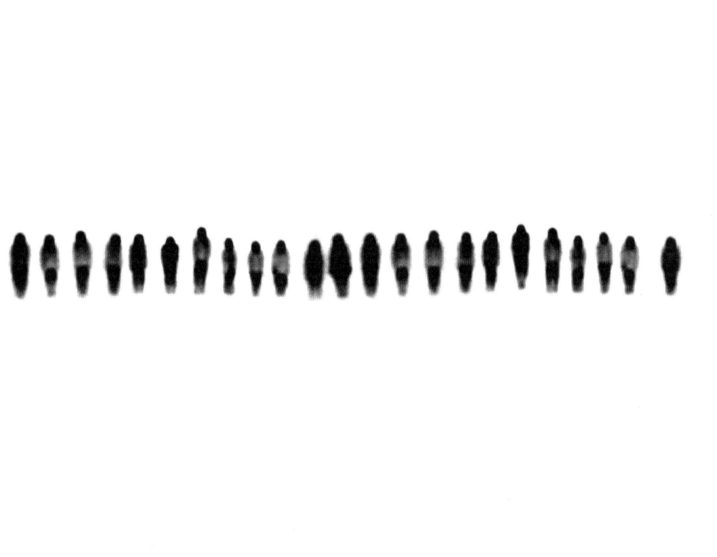

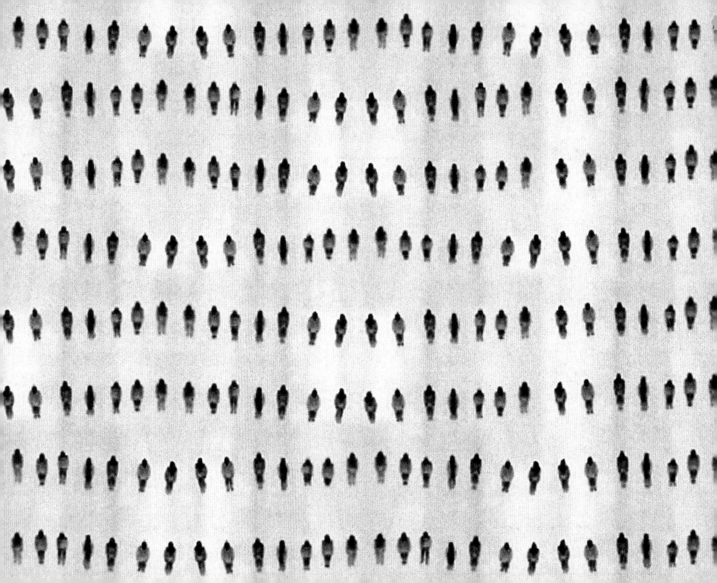

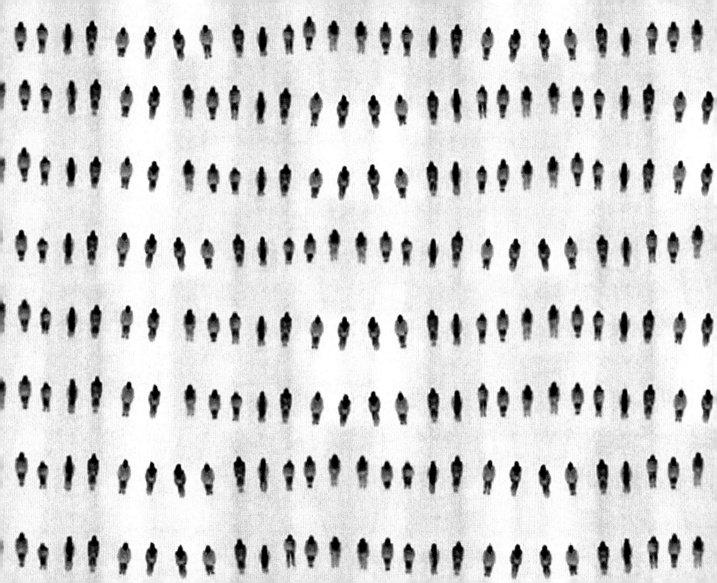

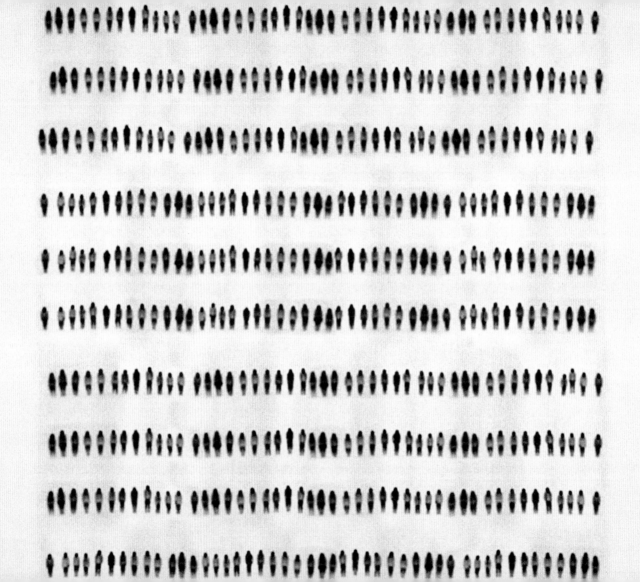

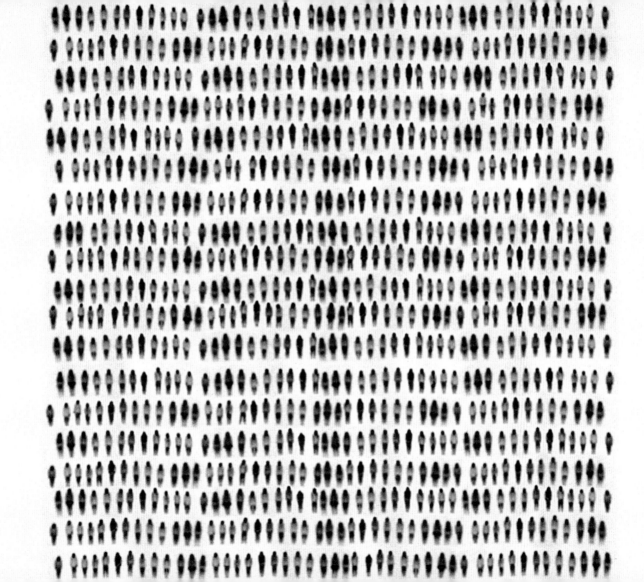

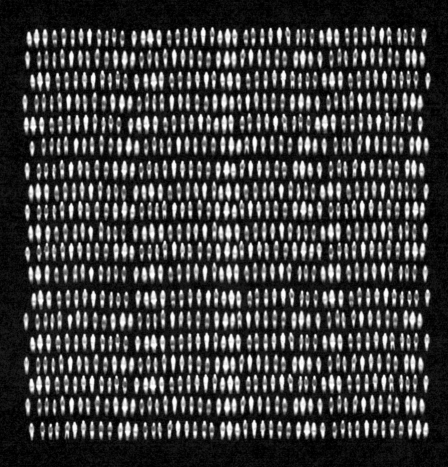

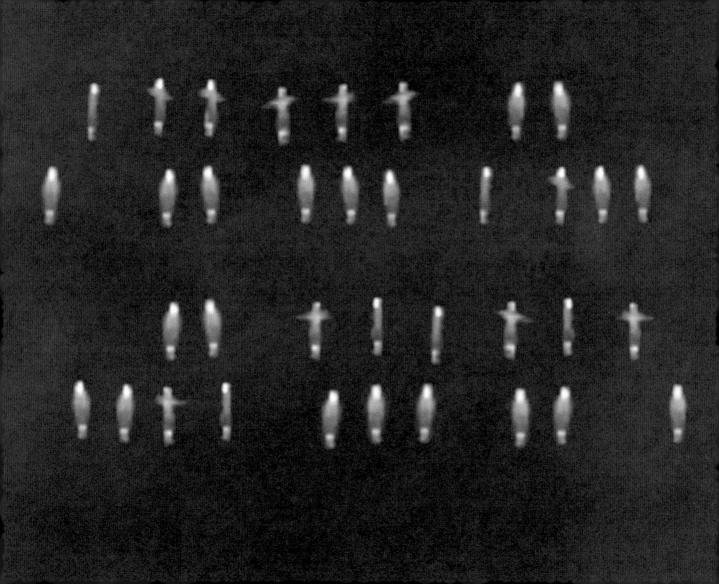

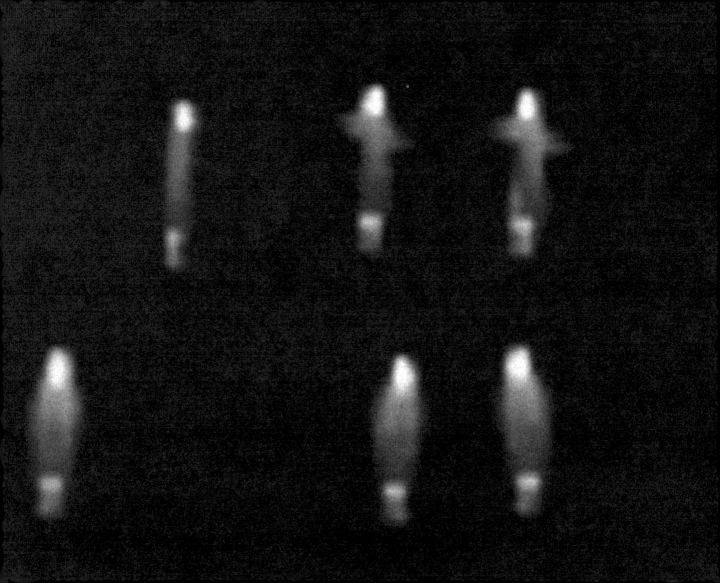

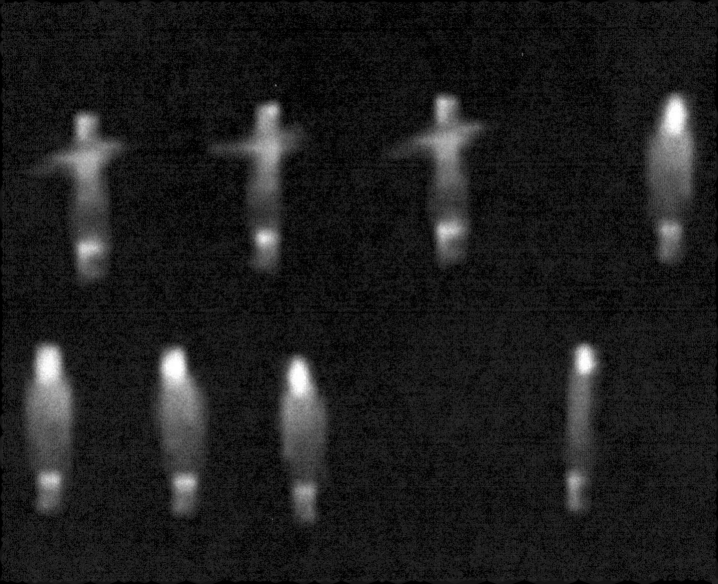

54

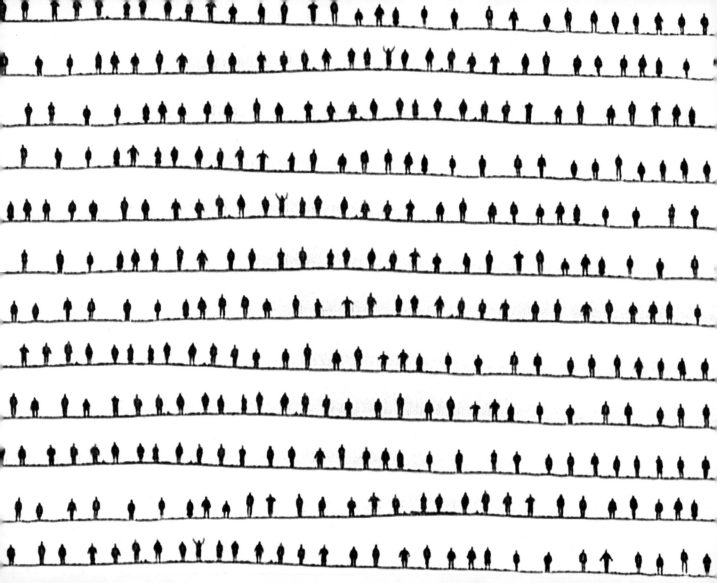

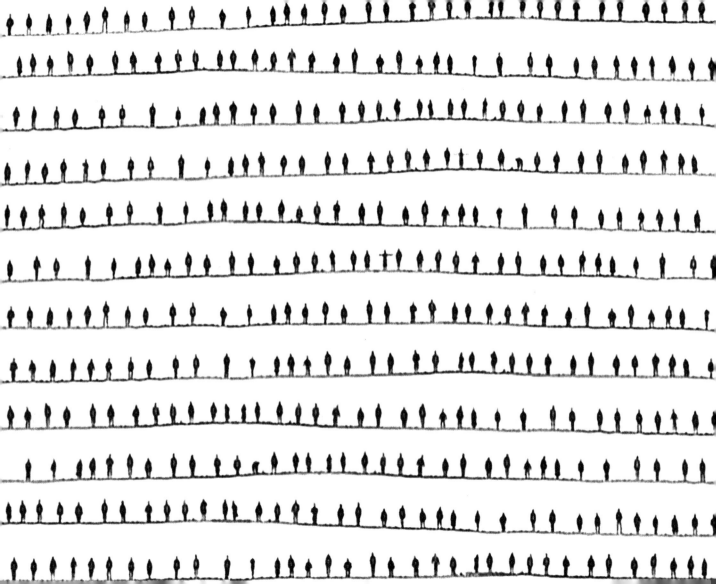

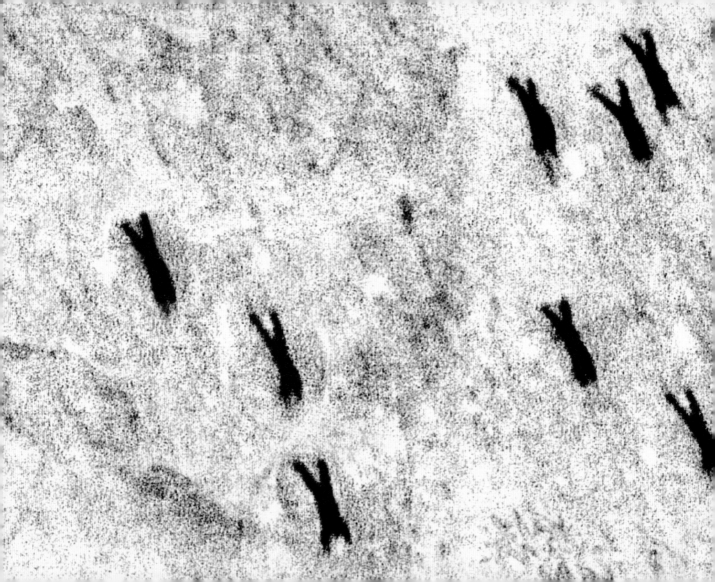

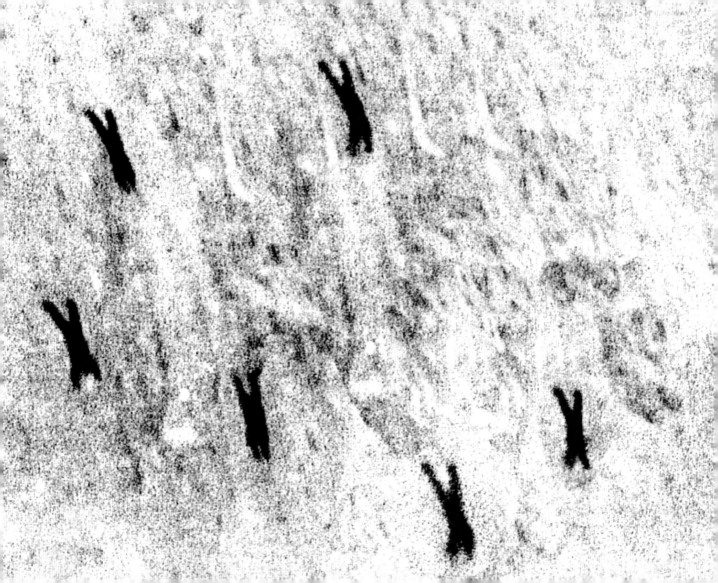

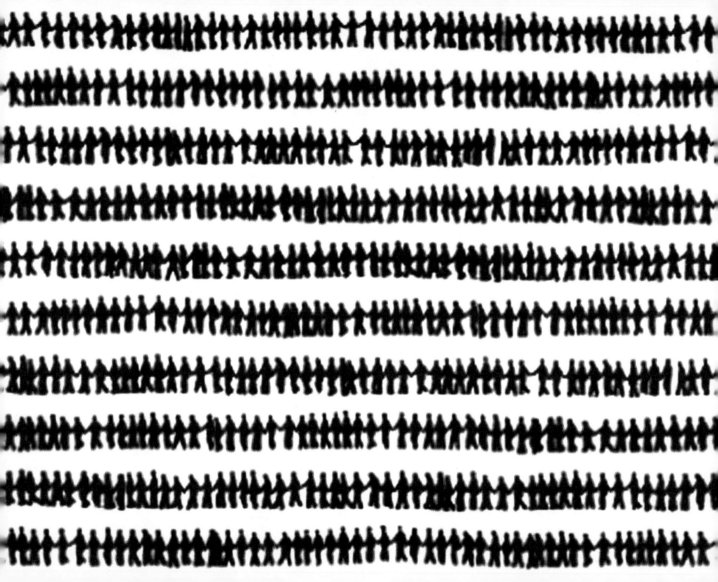

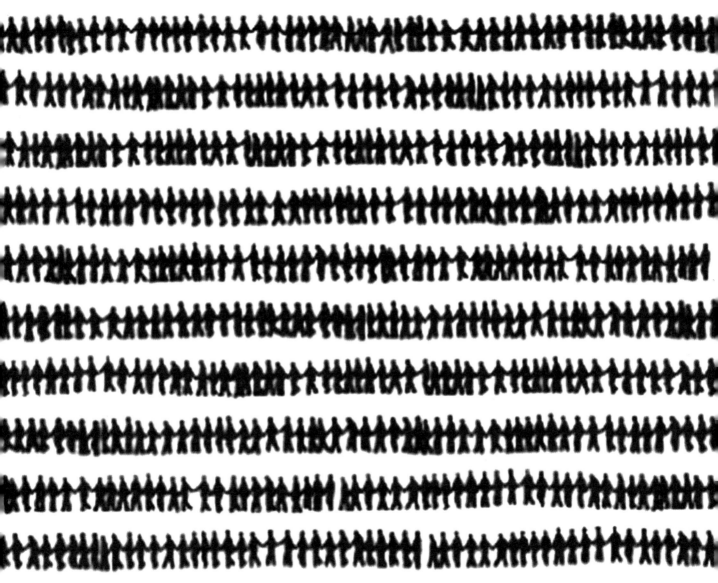

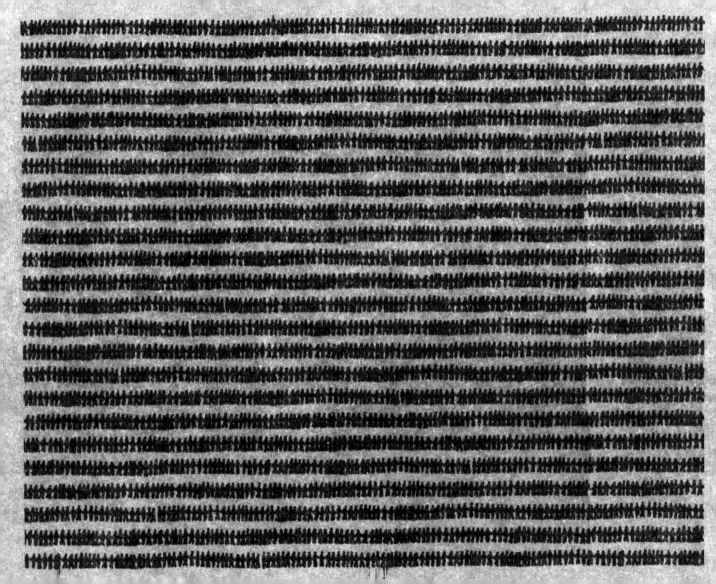

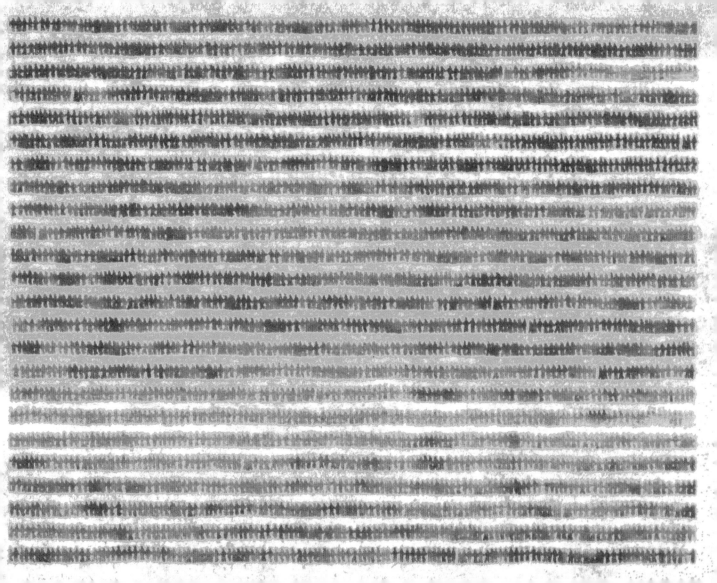

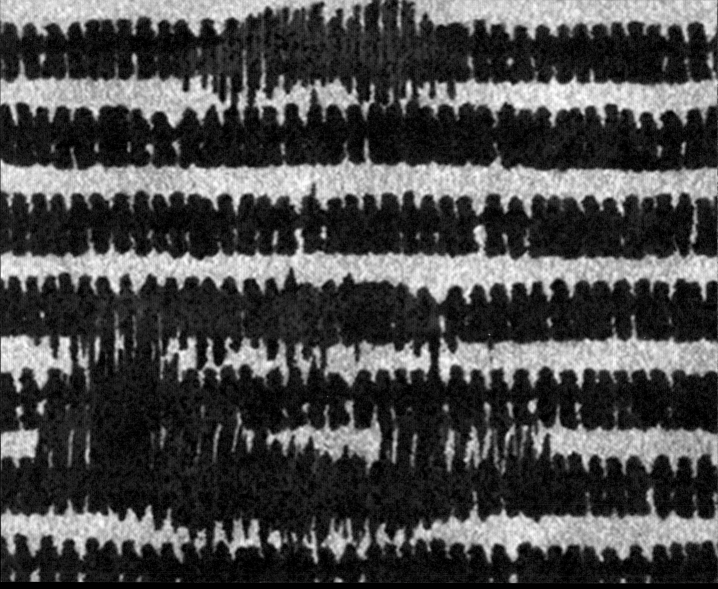

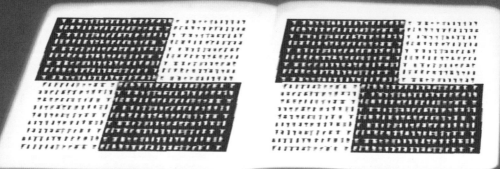

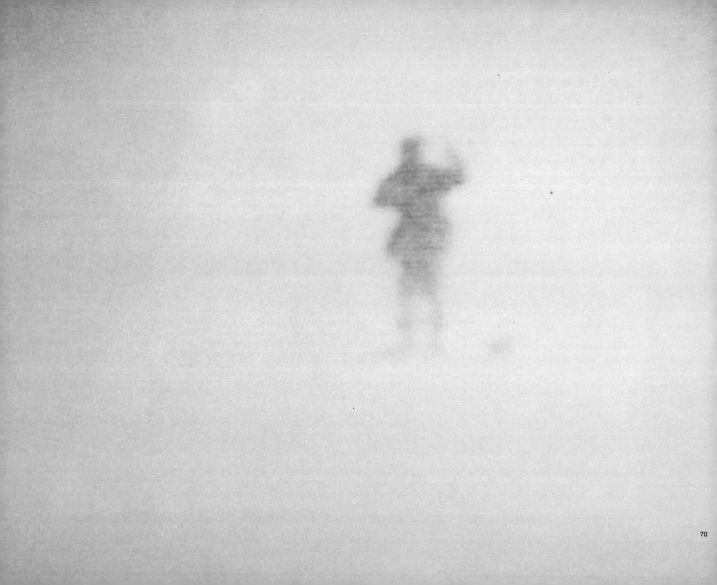

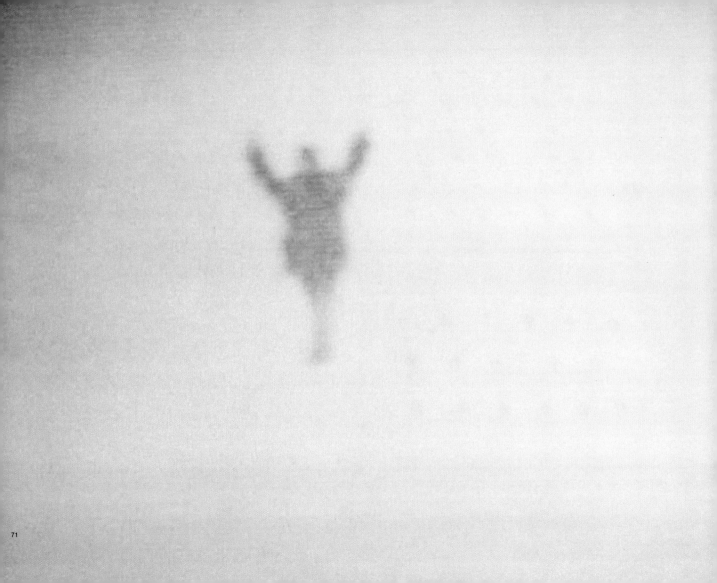

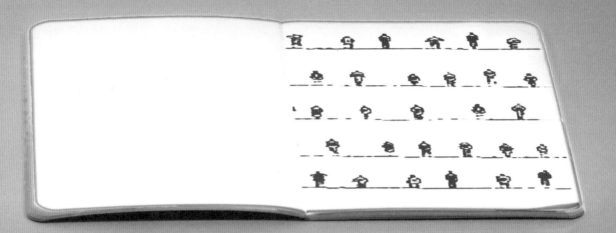
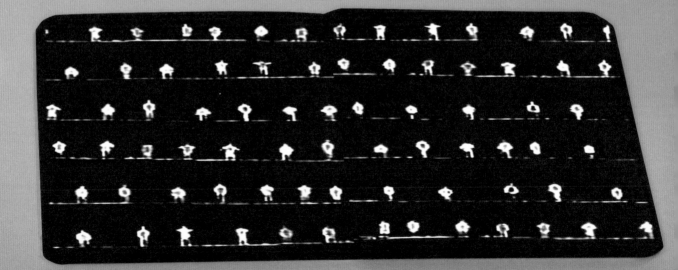

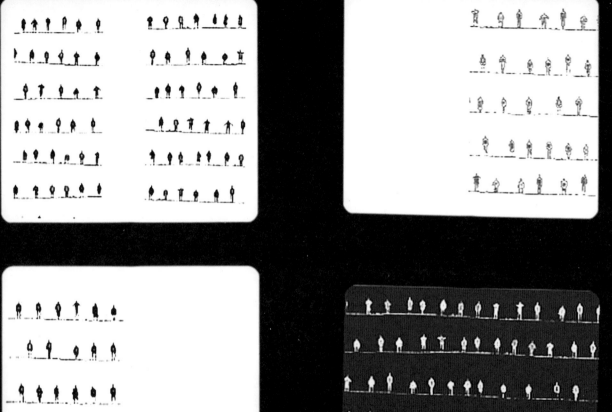

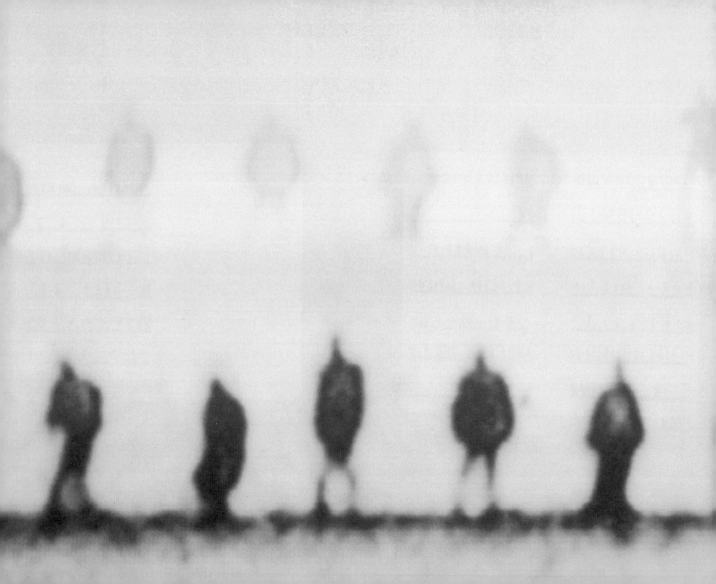

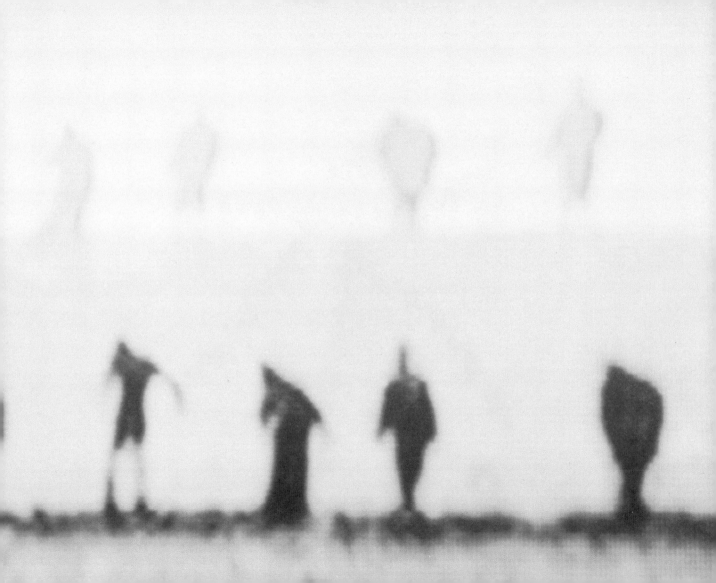

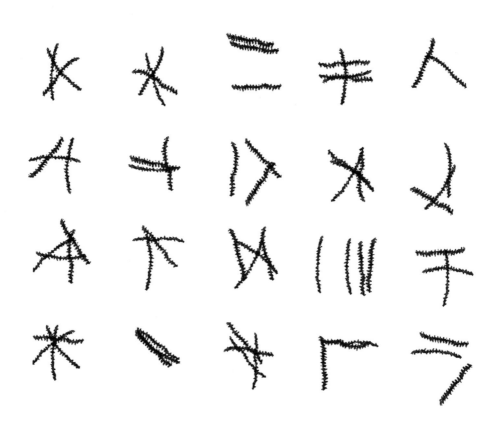

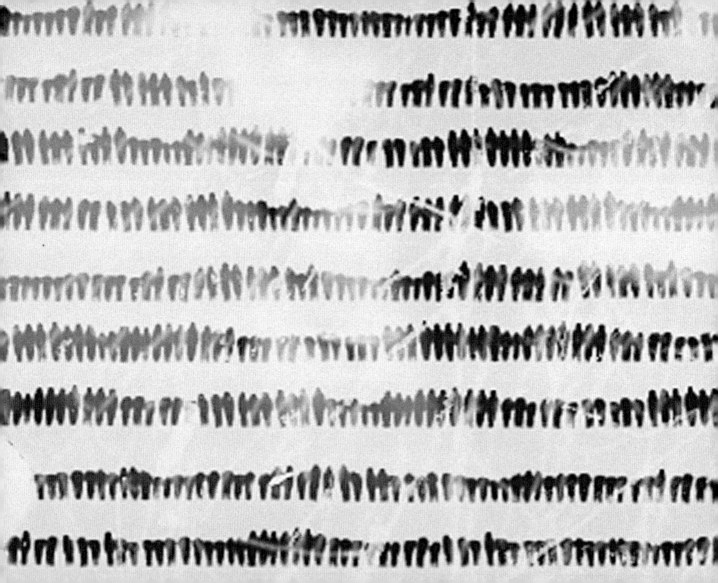

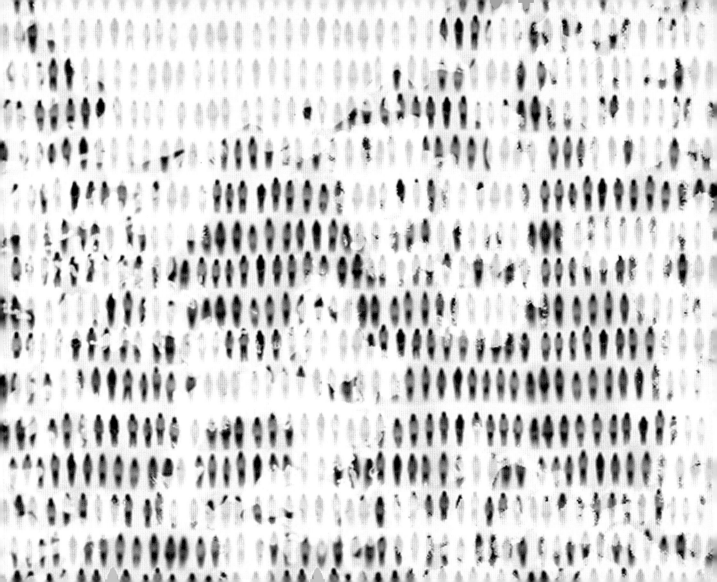

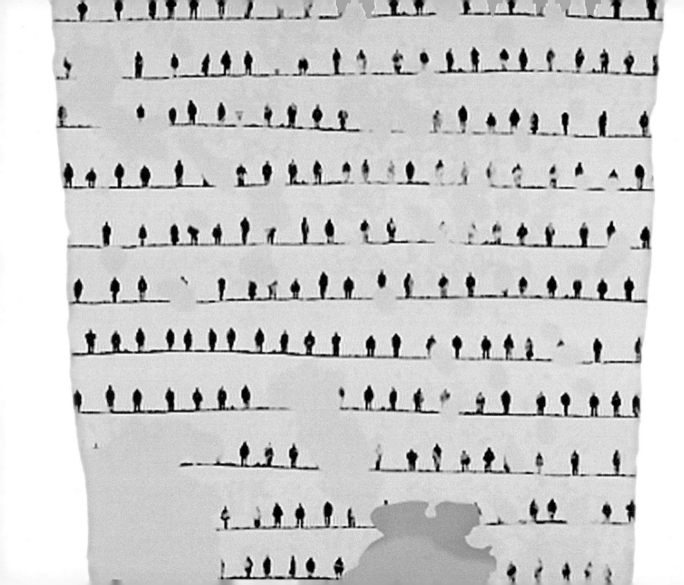

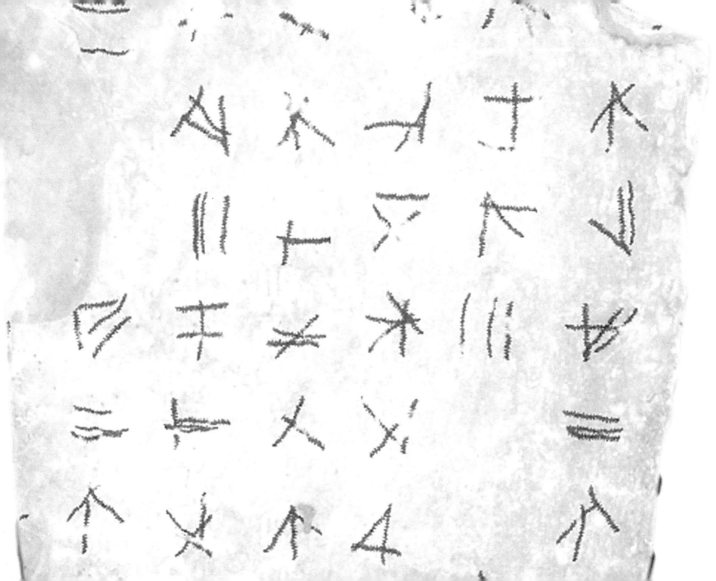

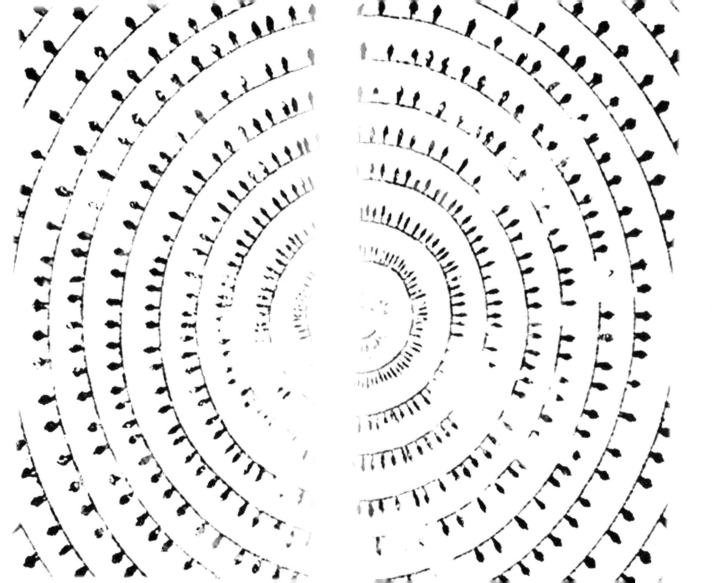

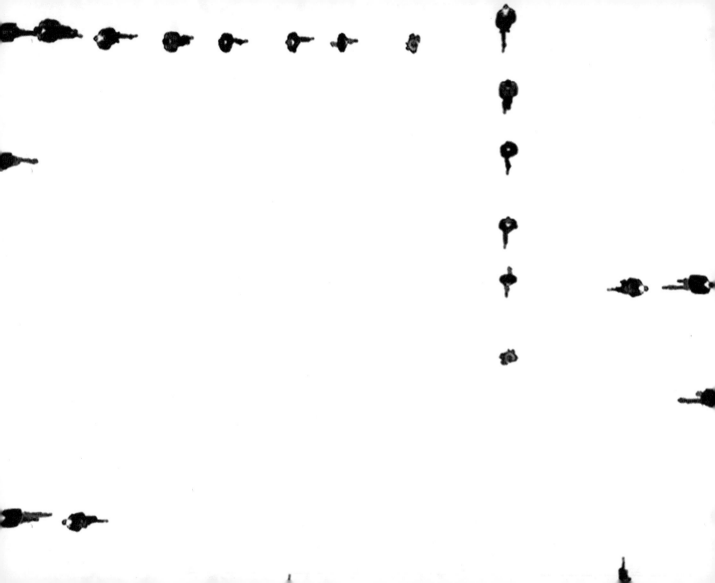

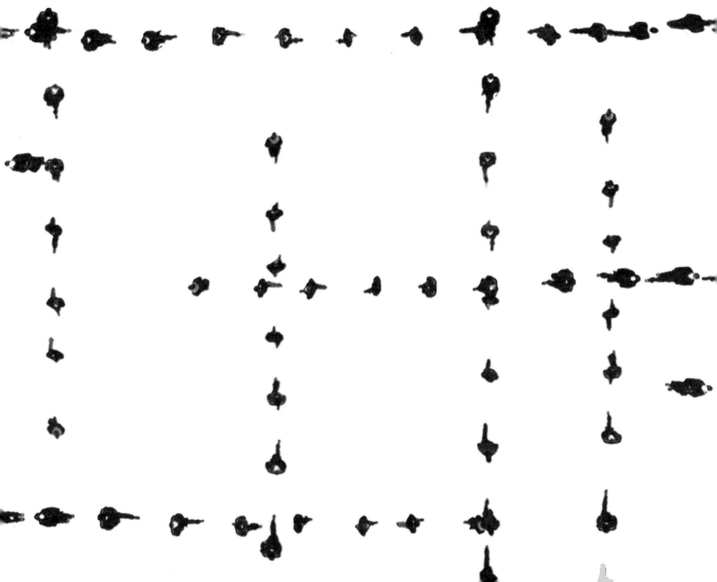

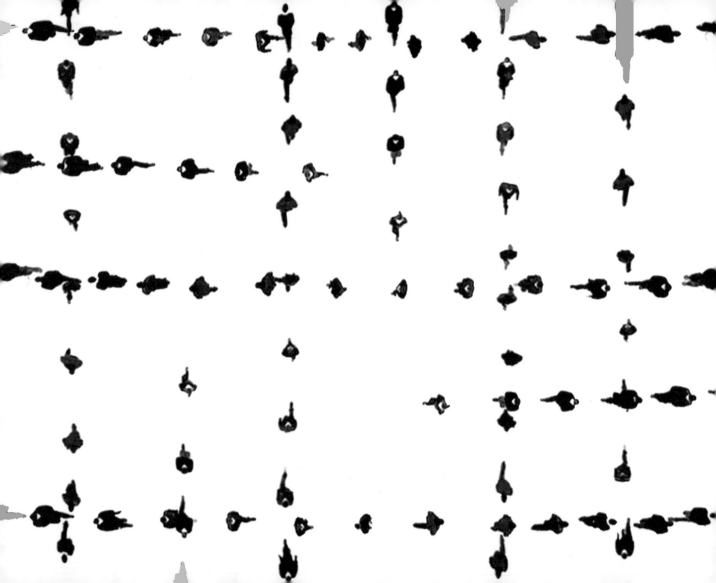

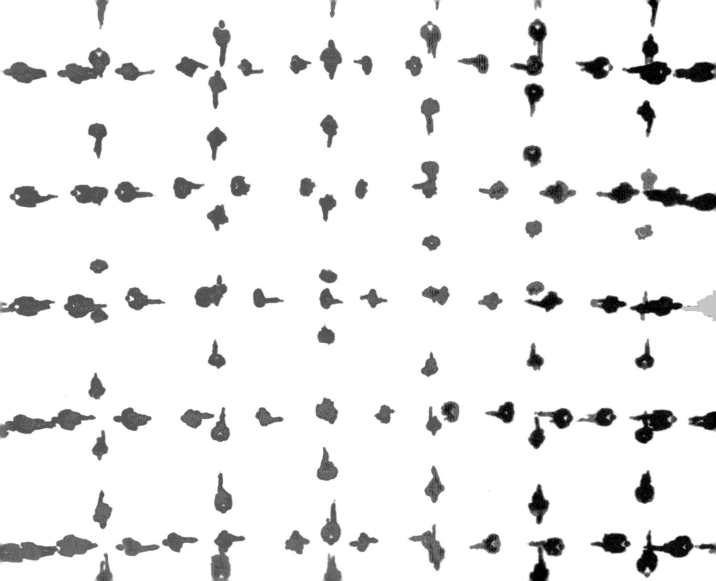

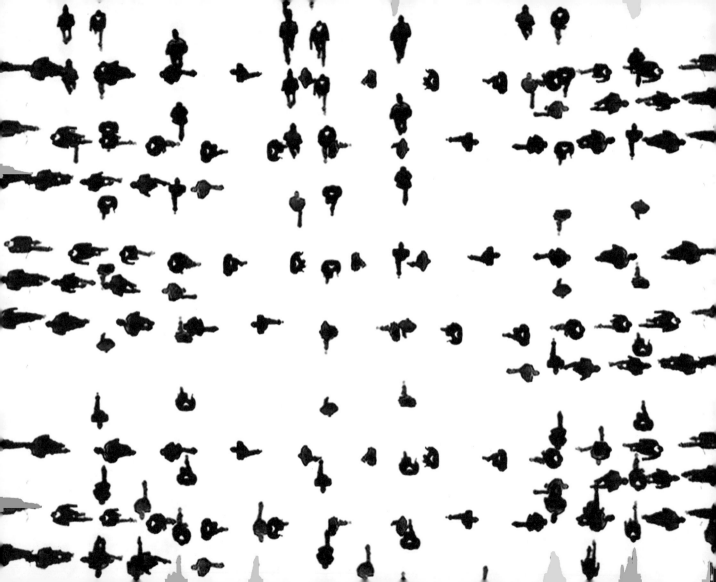

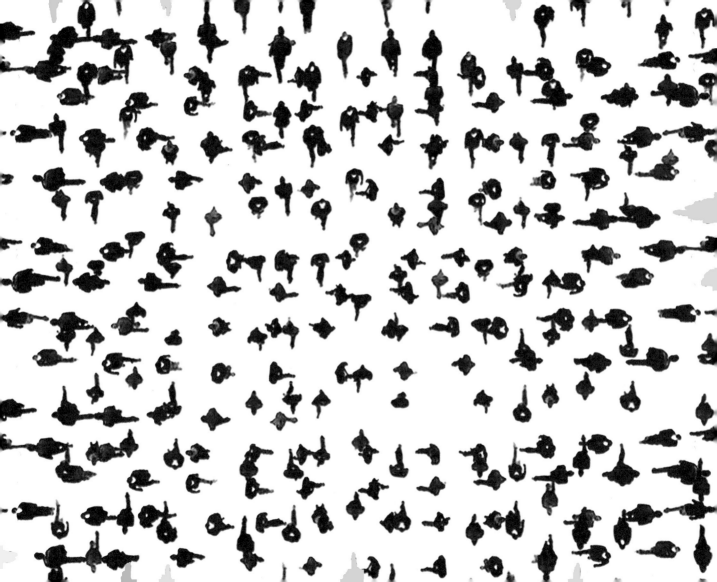

104

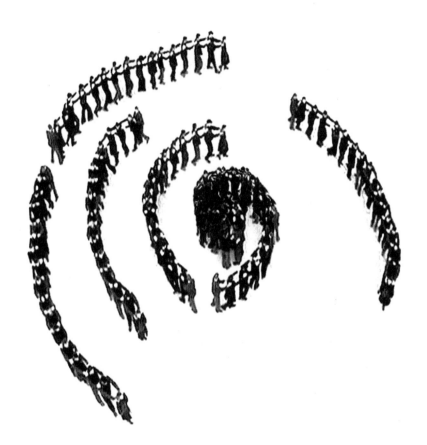

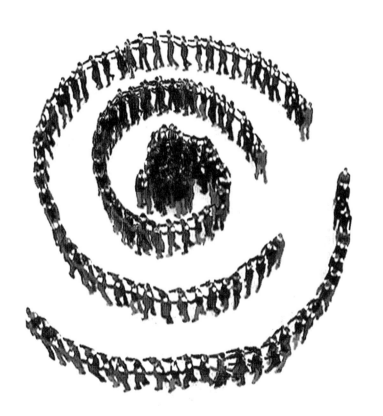

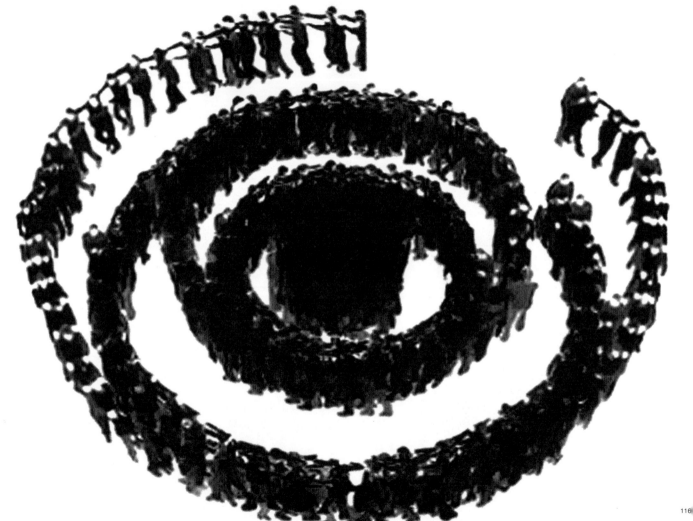

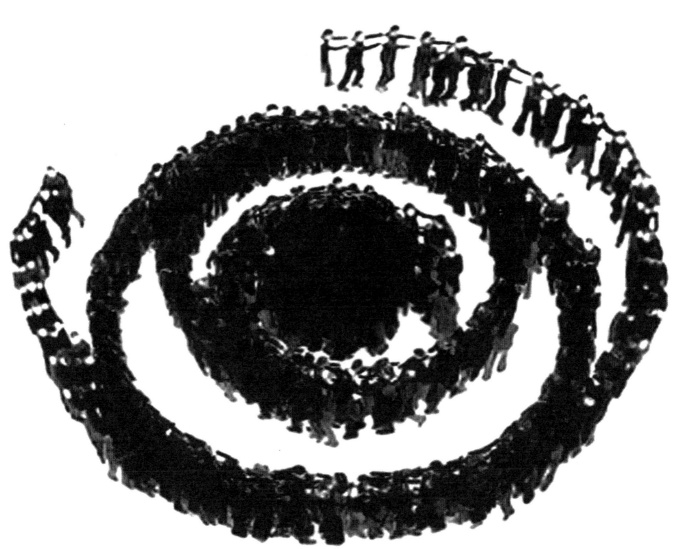

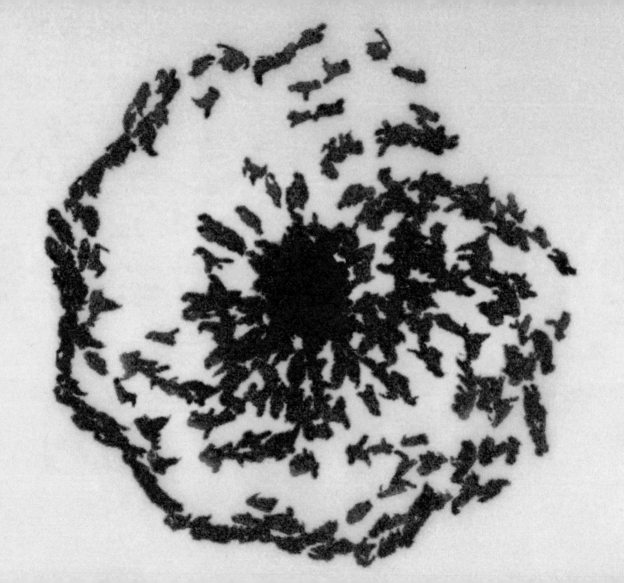

118

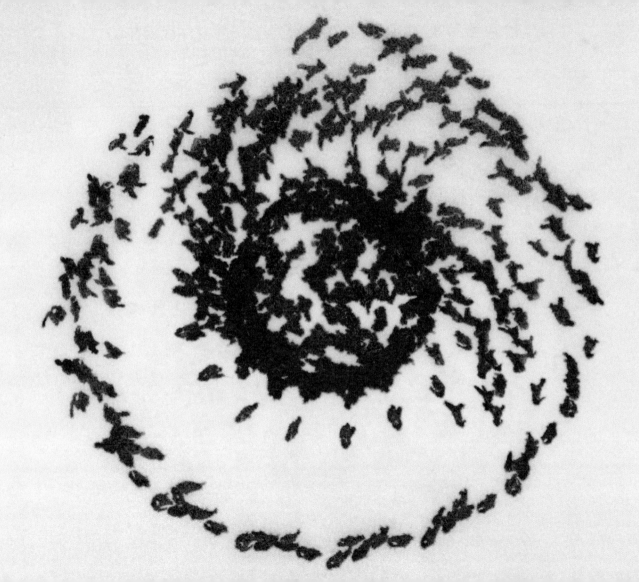

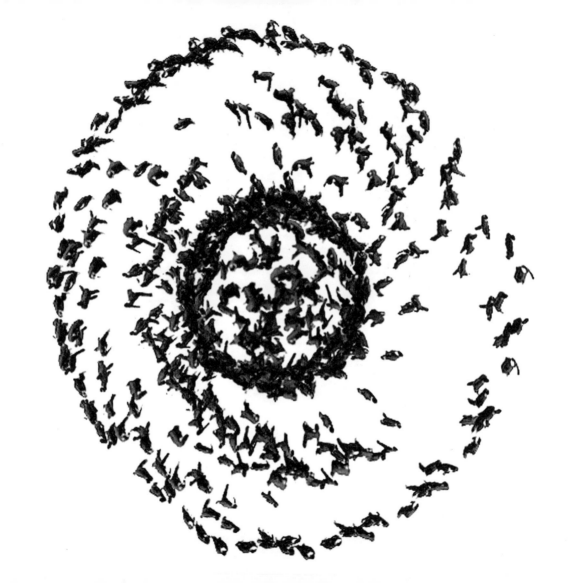

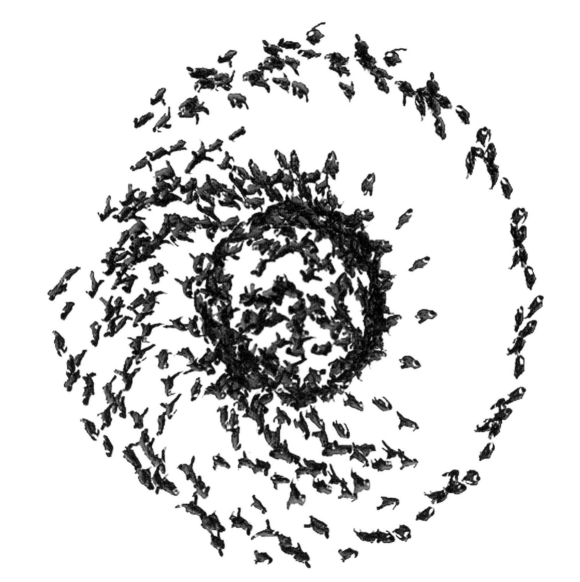

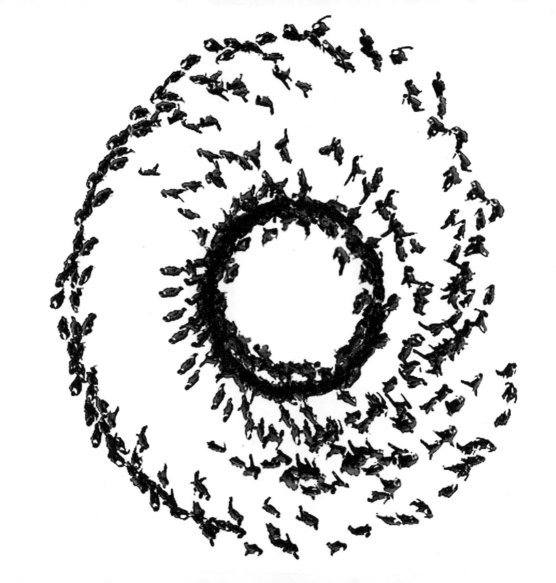

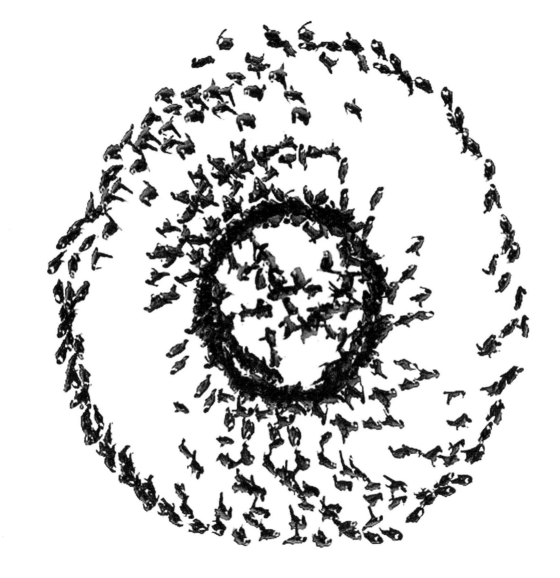

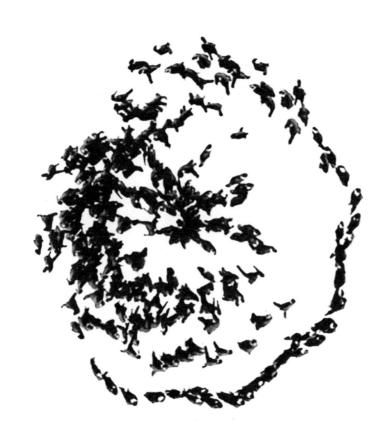

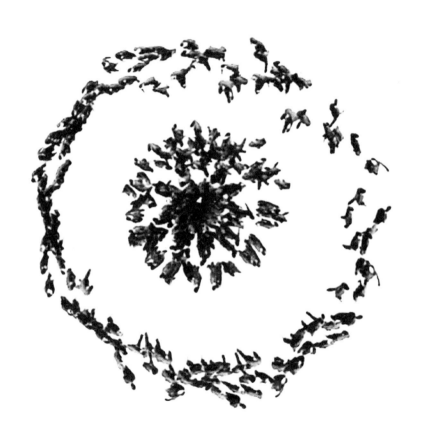

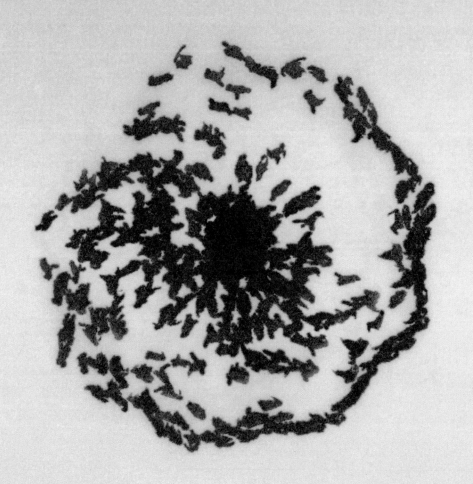

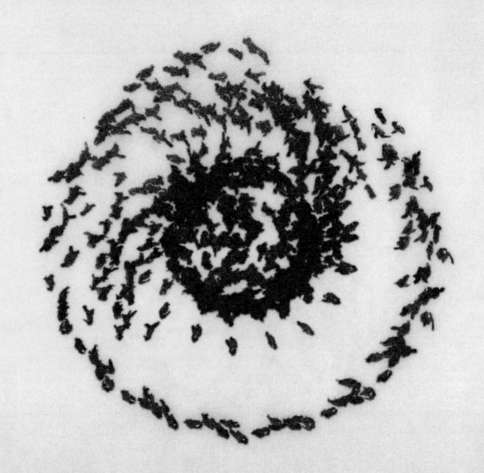

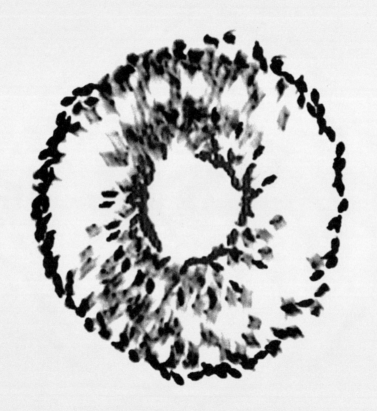

128

29

132

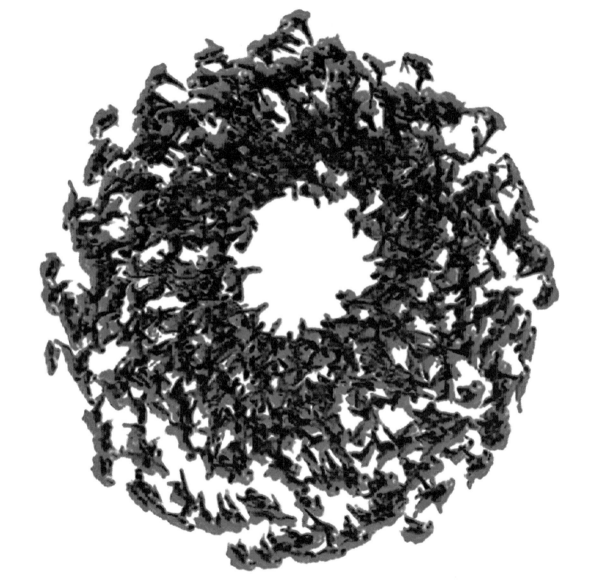

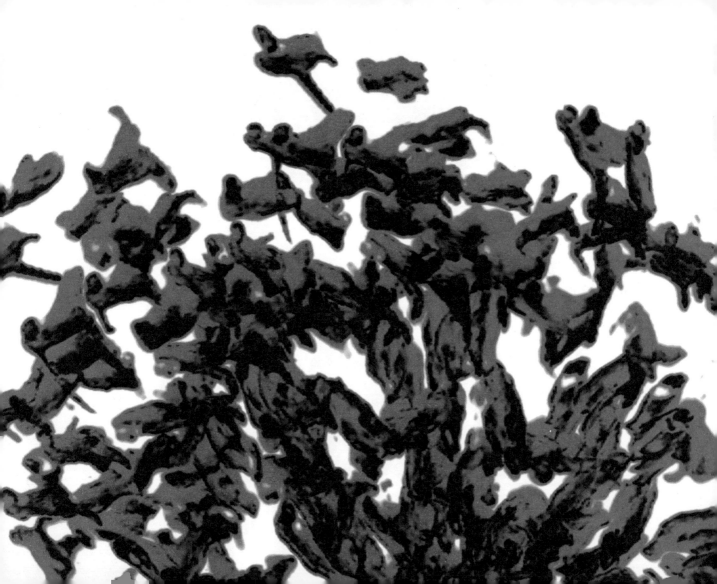

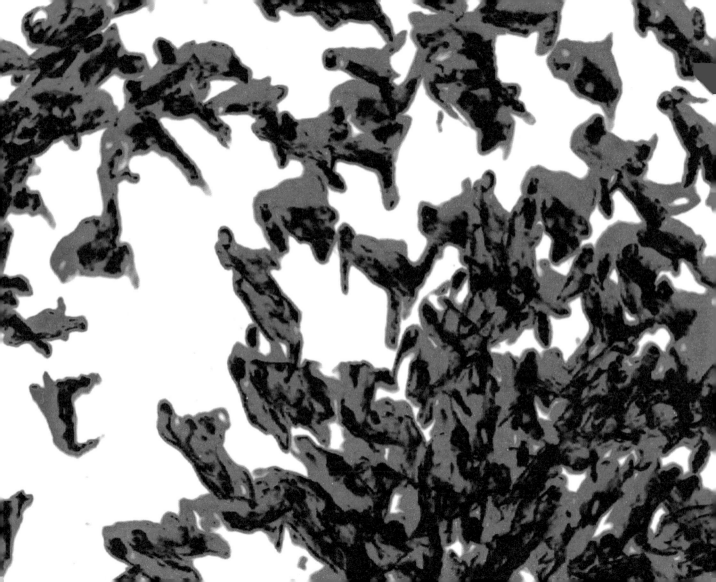

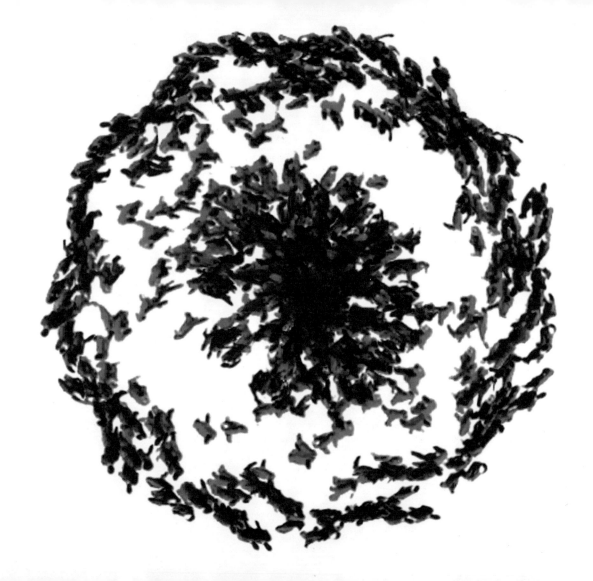

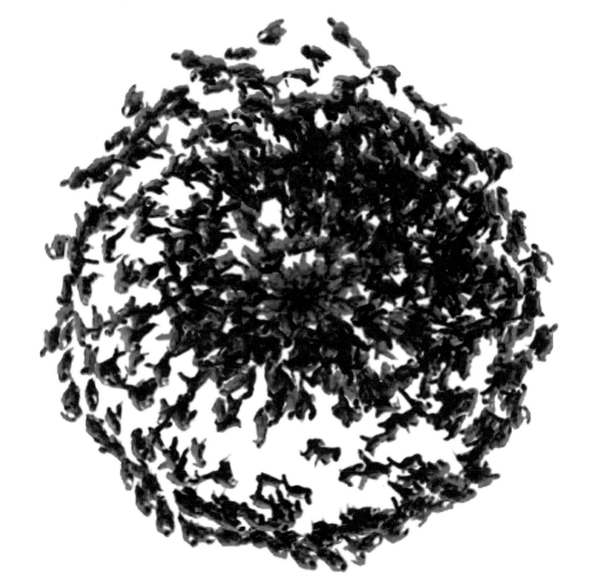
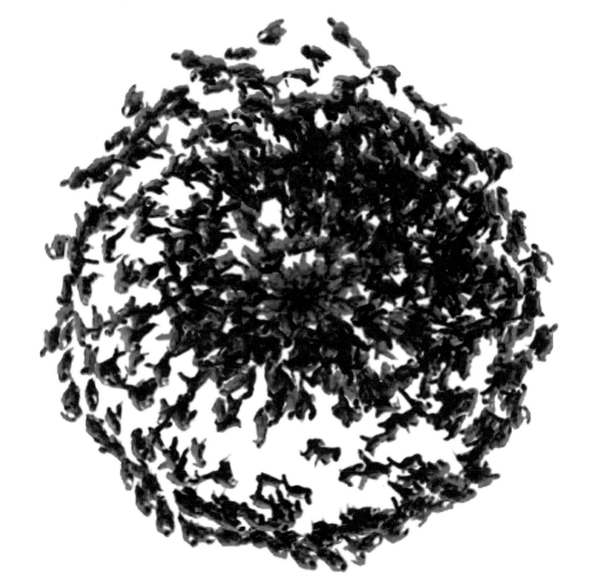

137

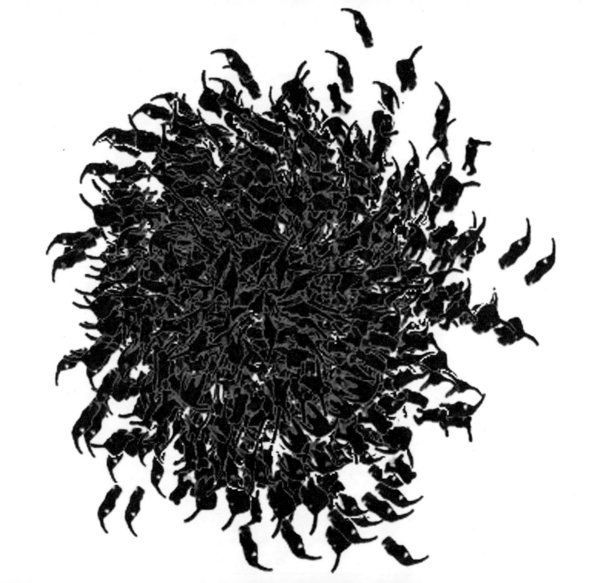

138

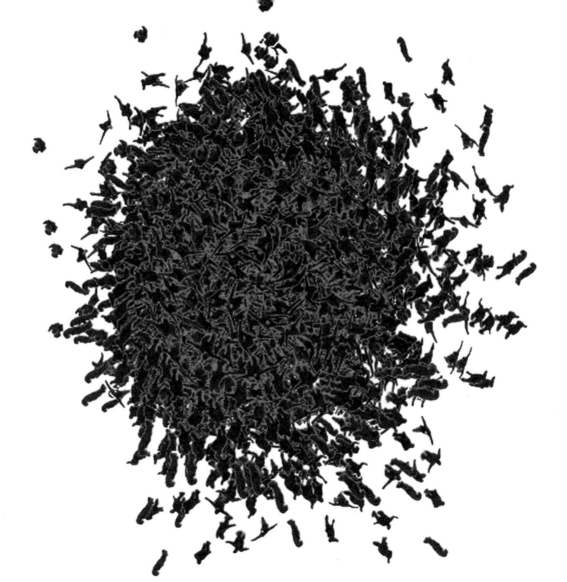

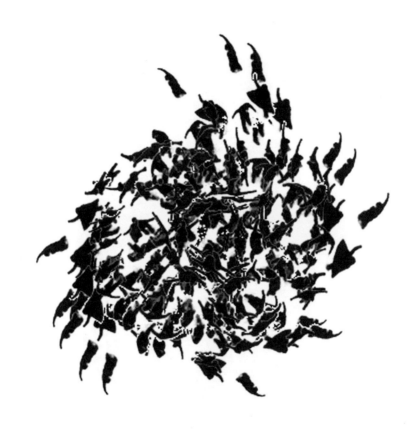

151

159

61

164

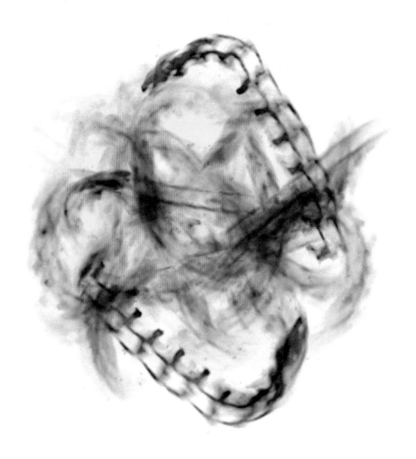

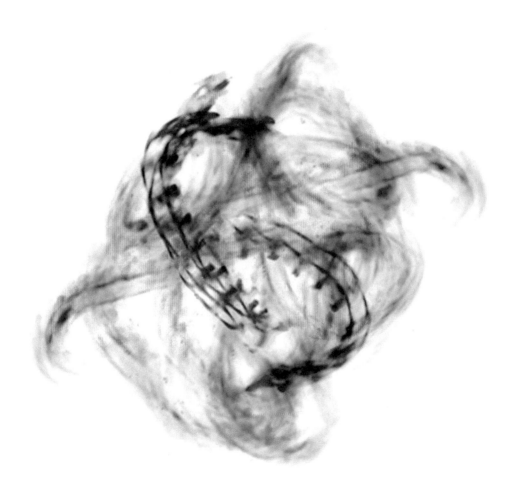

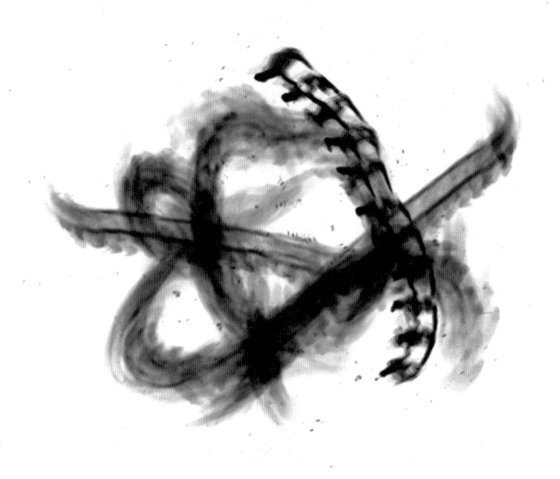

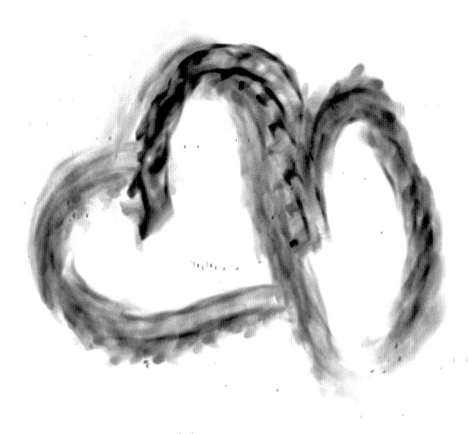

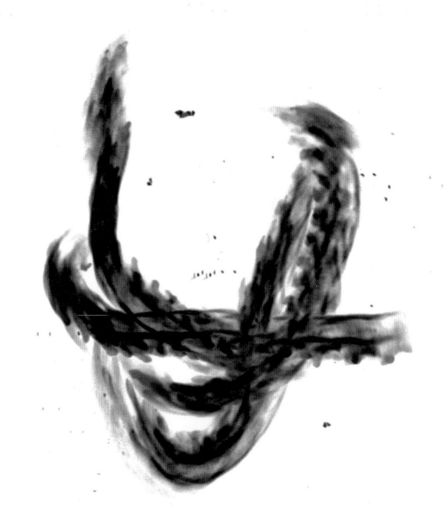

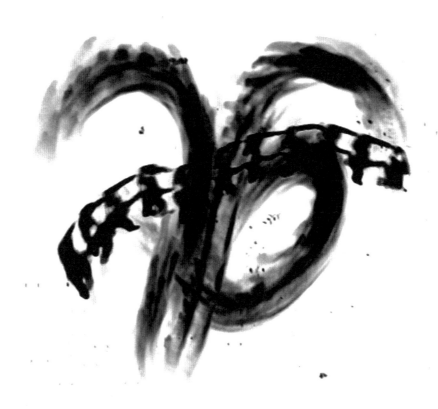

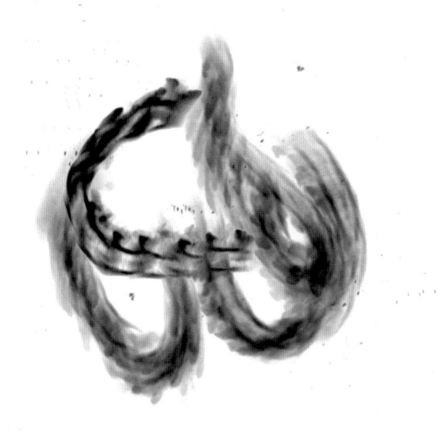

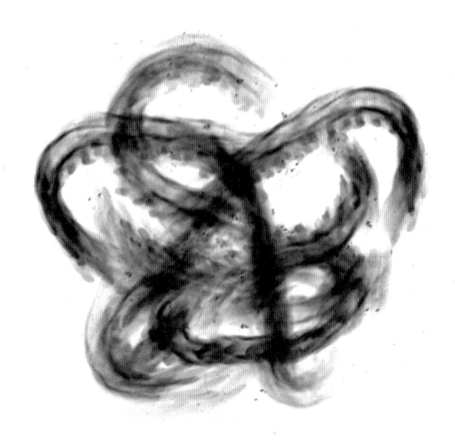

183

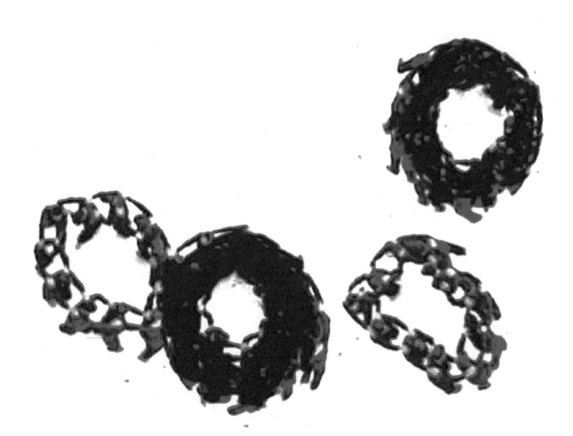

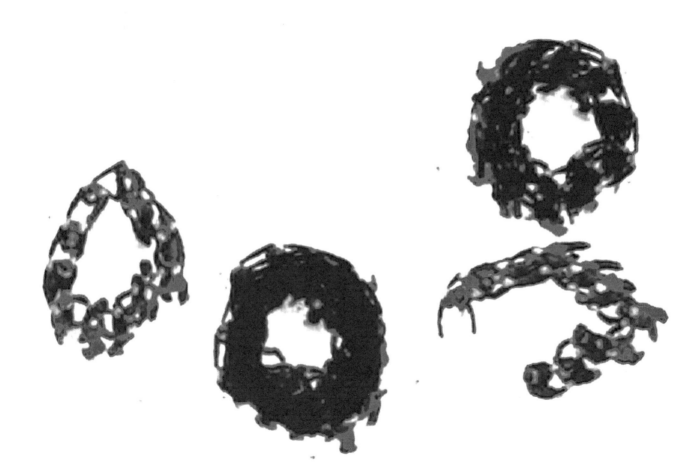

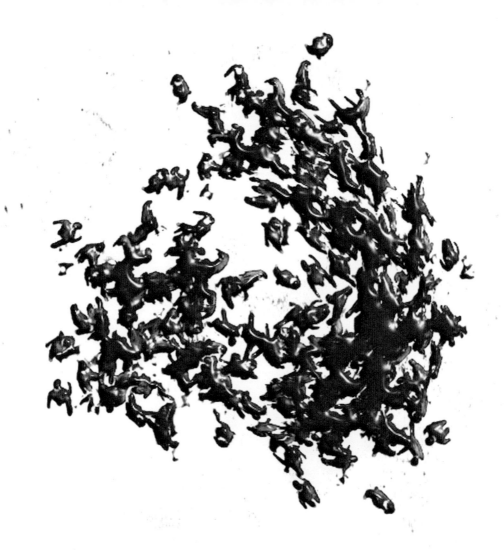

190

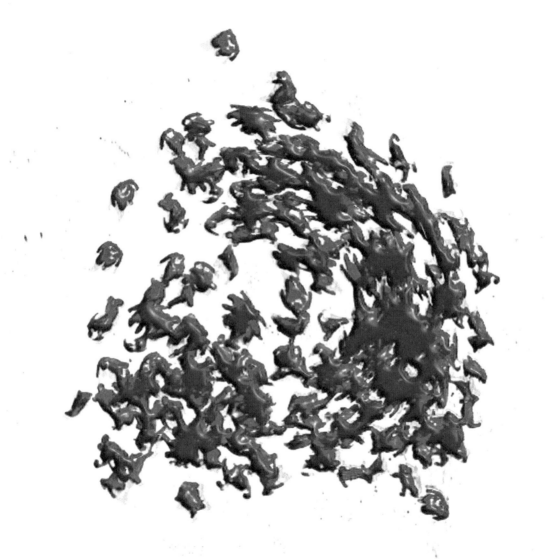

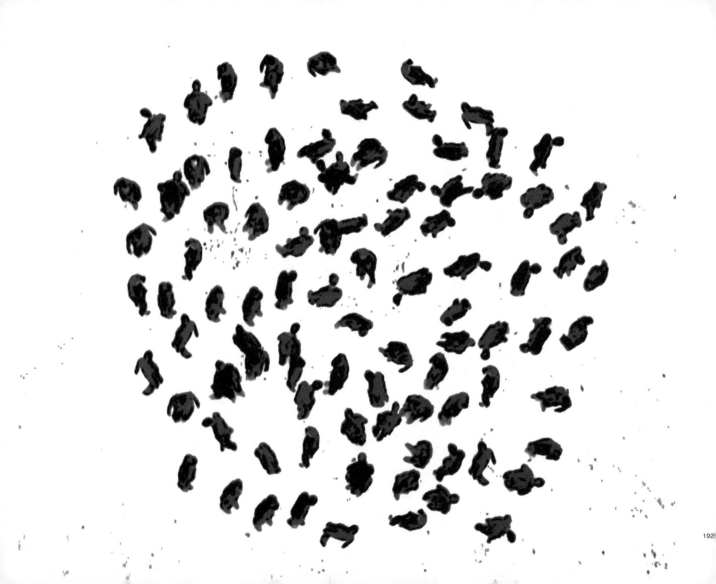

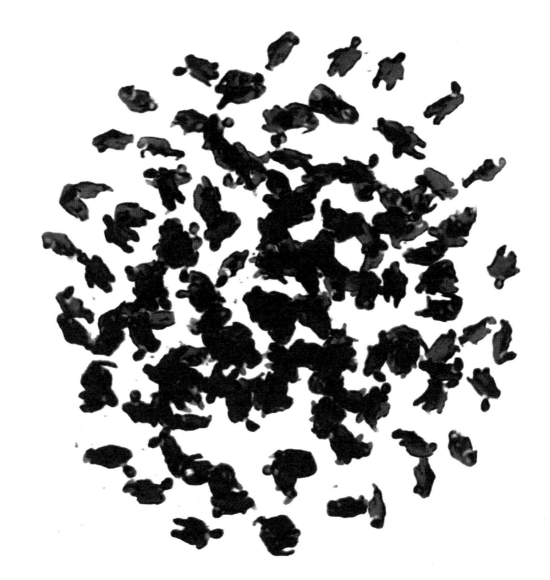

CULTURES

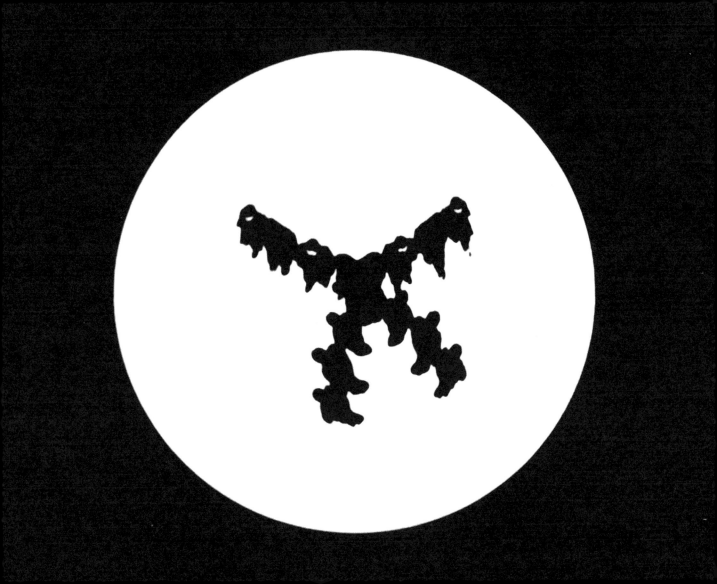

DATA ZONE

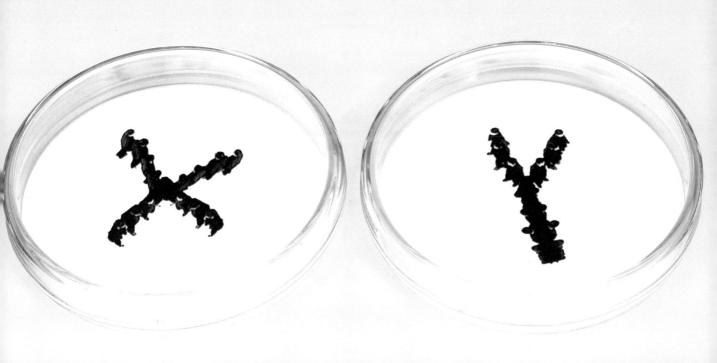

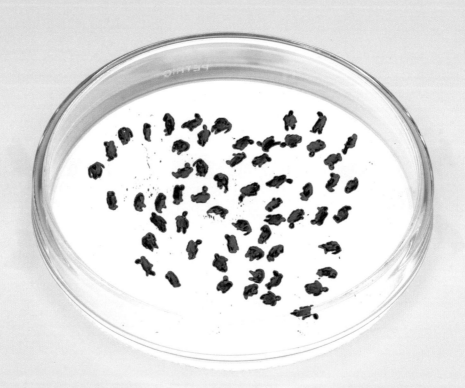

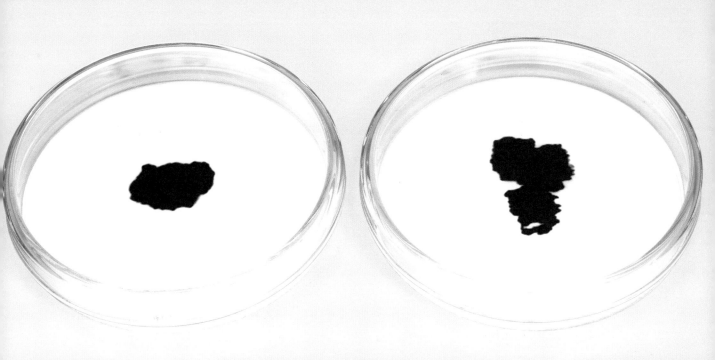

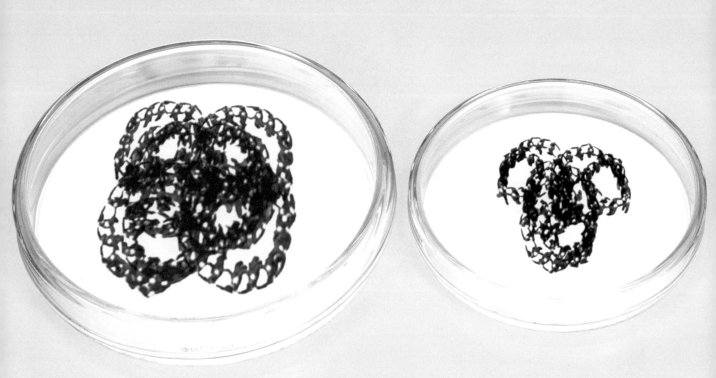

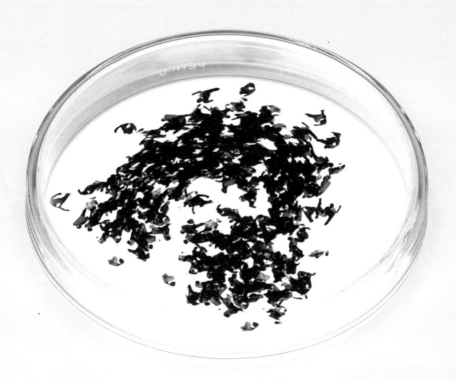

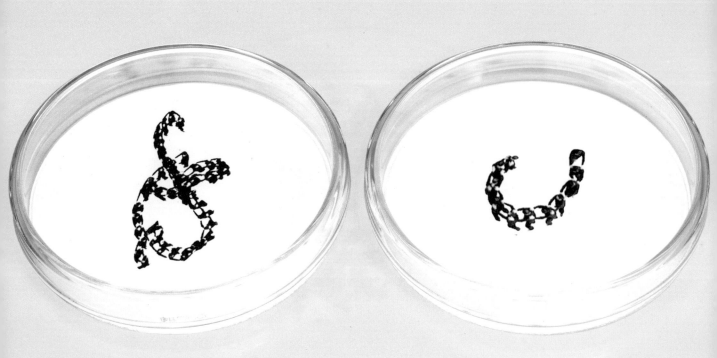

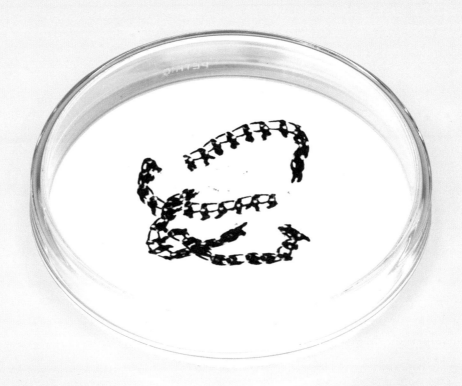

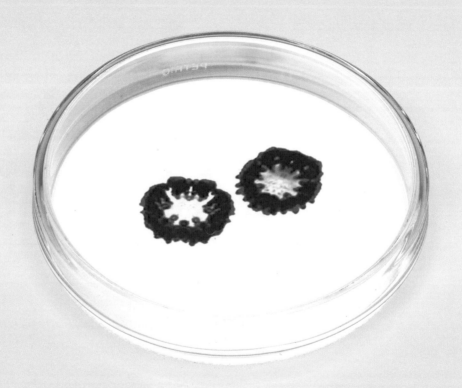

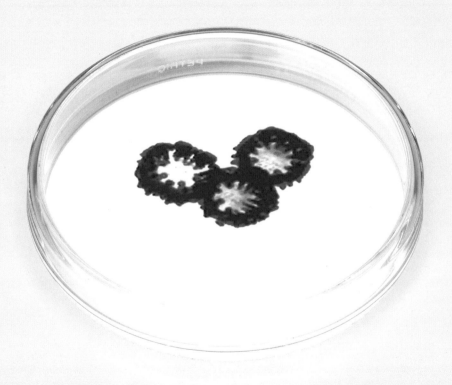

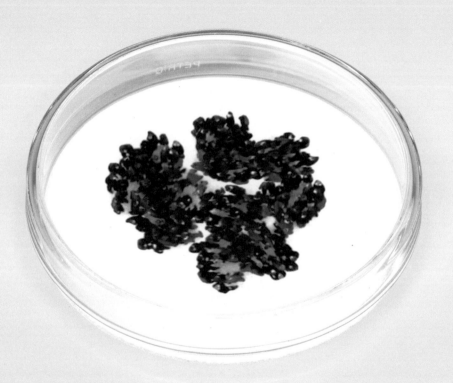

21

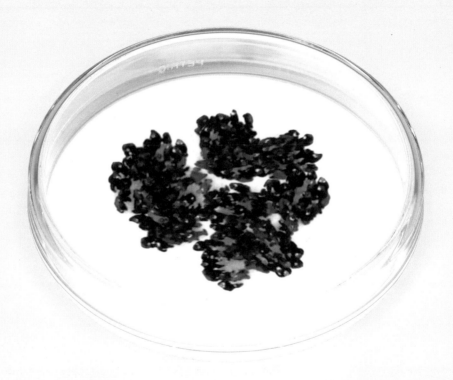

213

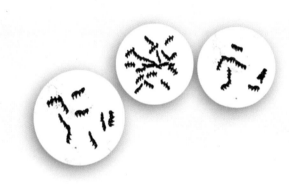

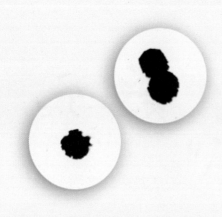
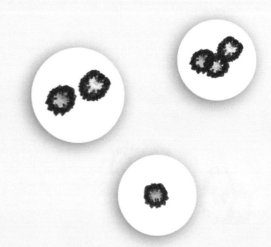

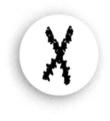

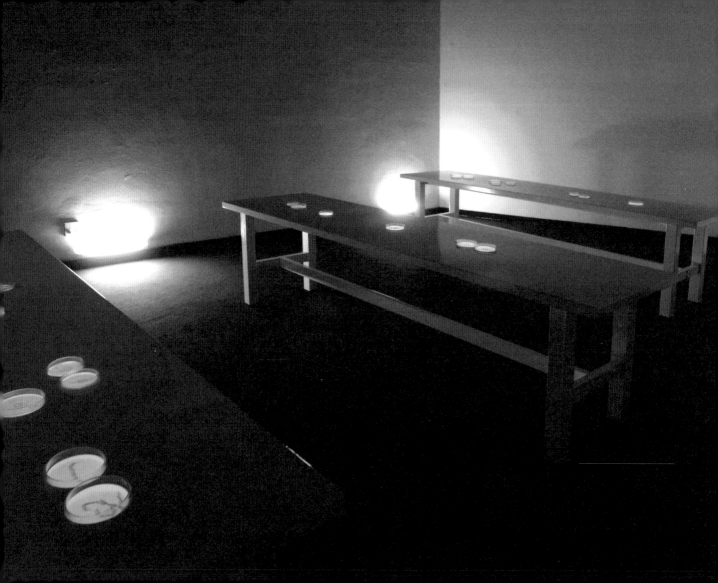

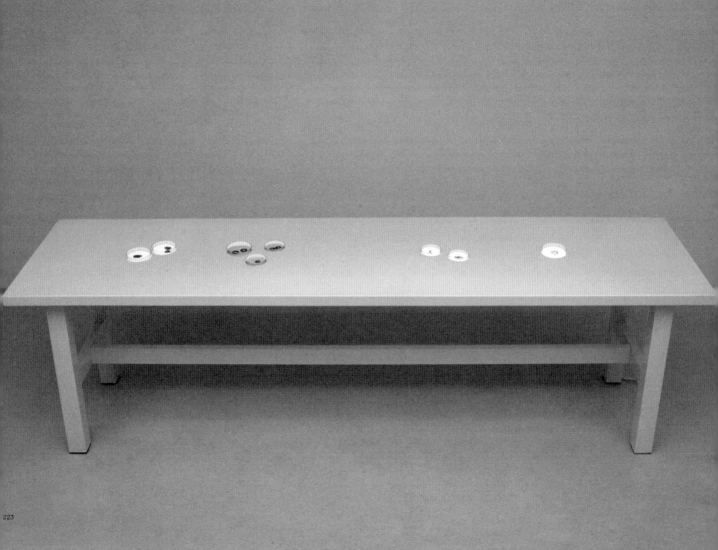

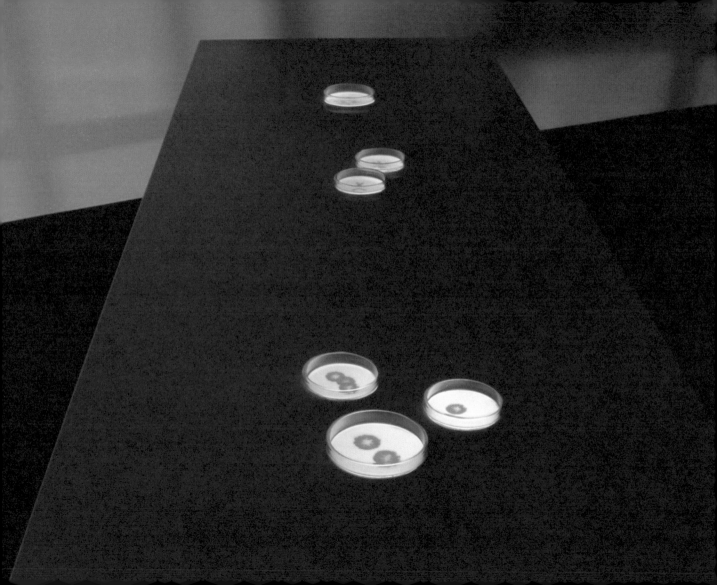

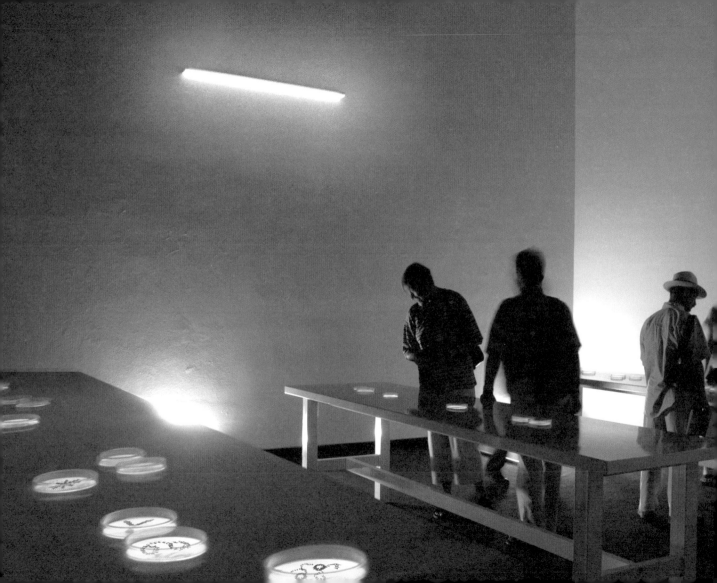

IN STONE

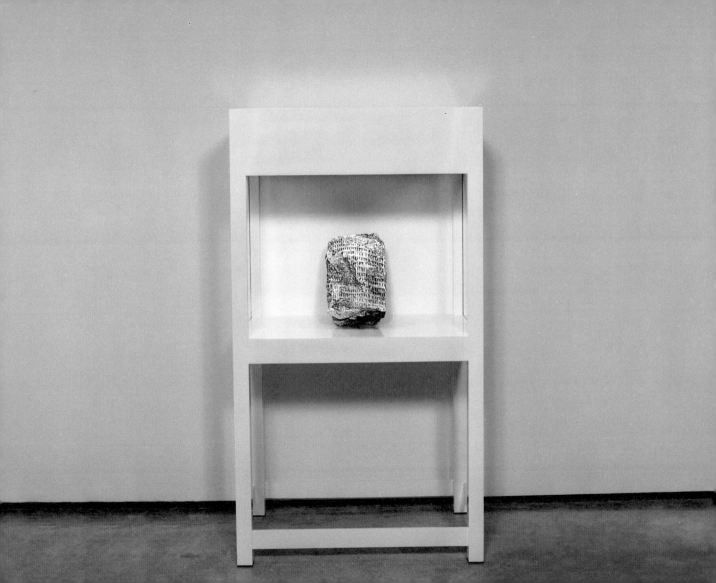

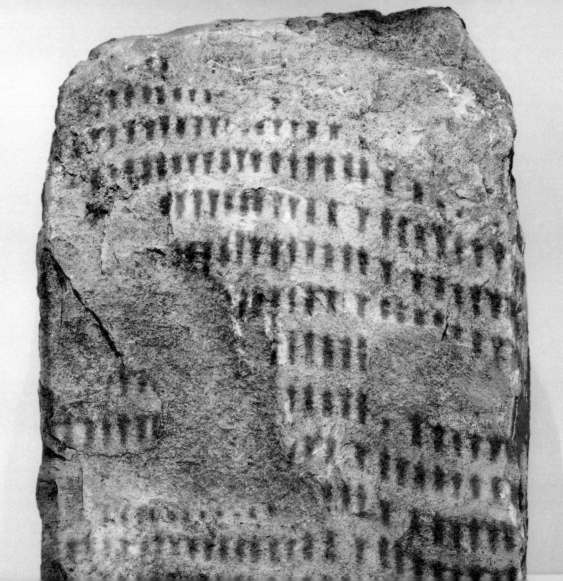

229

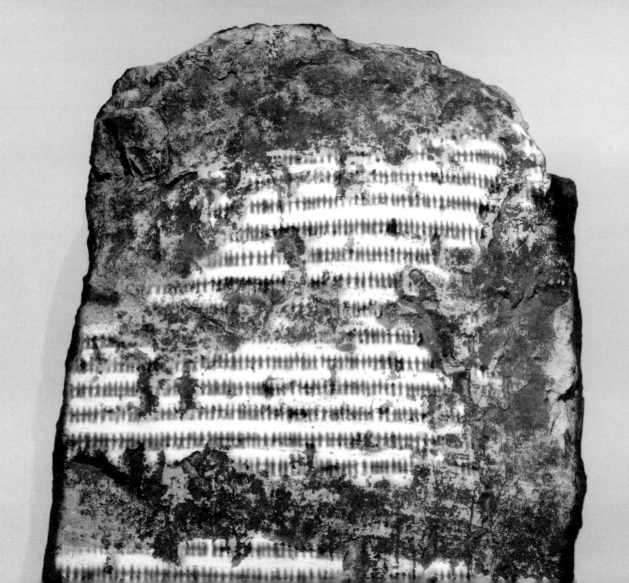

238

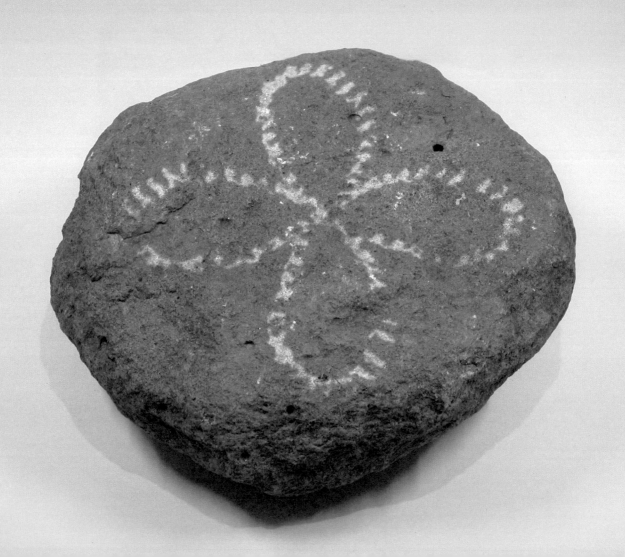

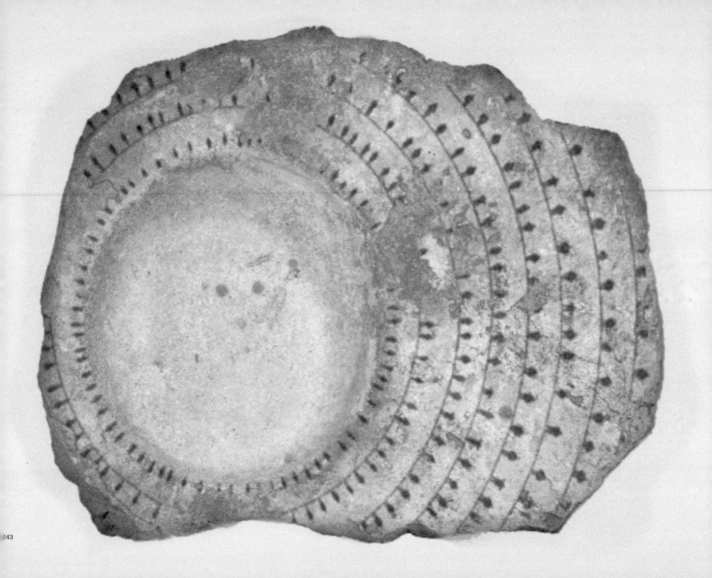

THE WELL

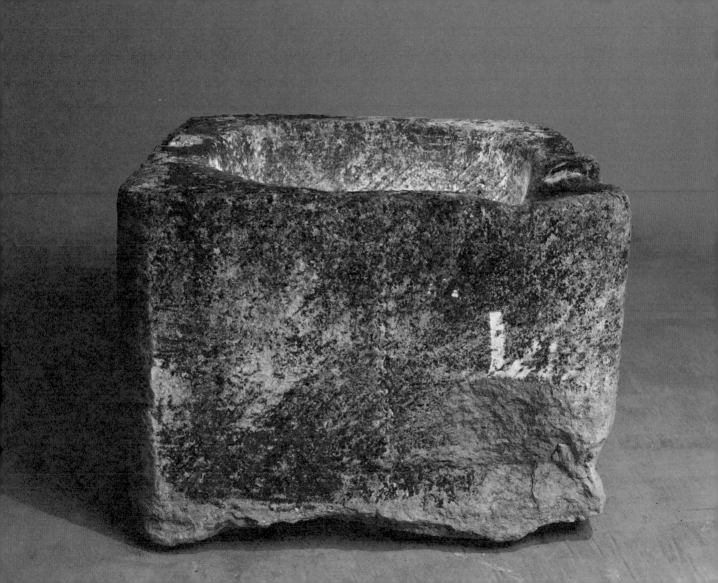

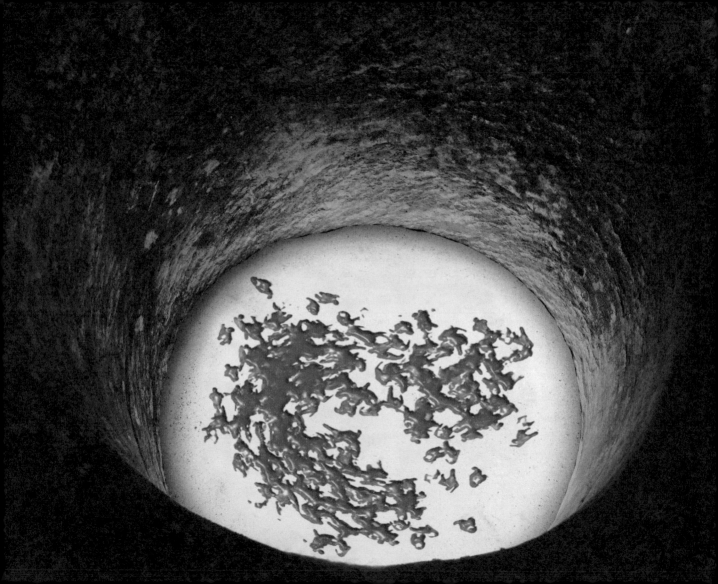

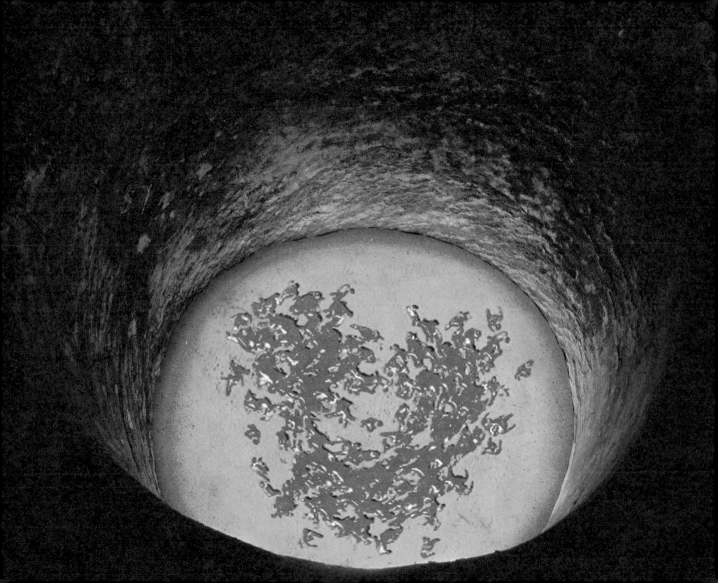

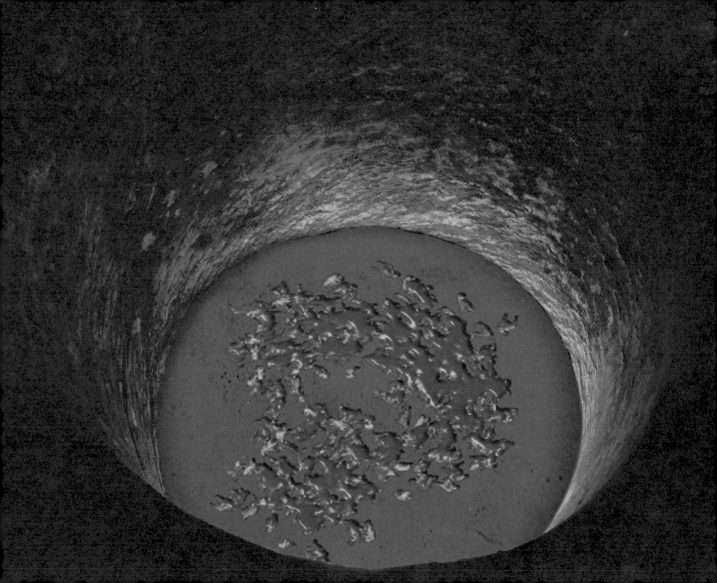

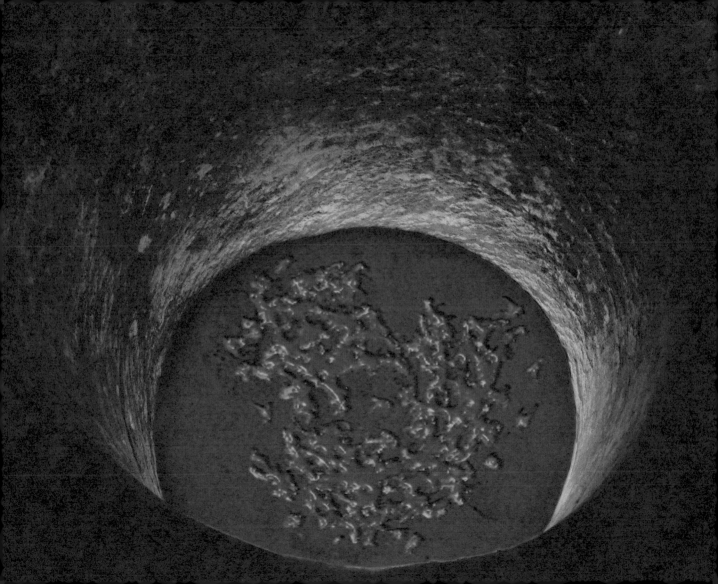

TABLETS

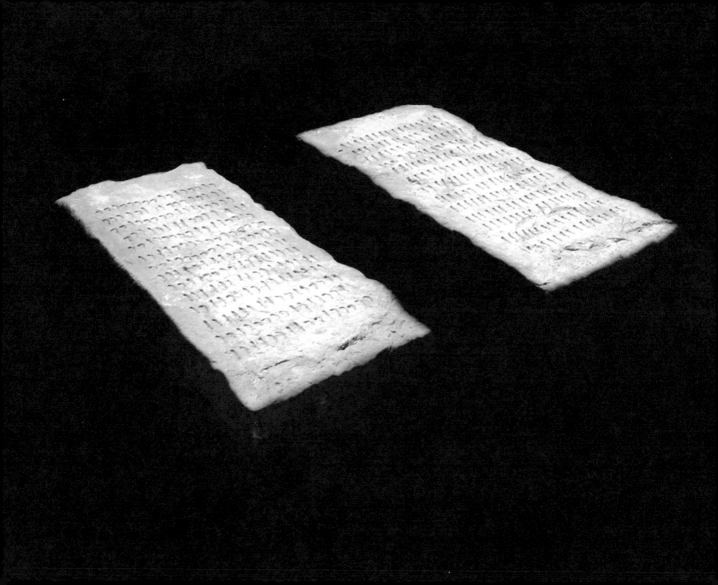

TIME LEFT

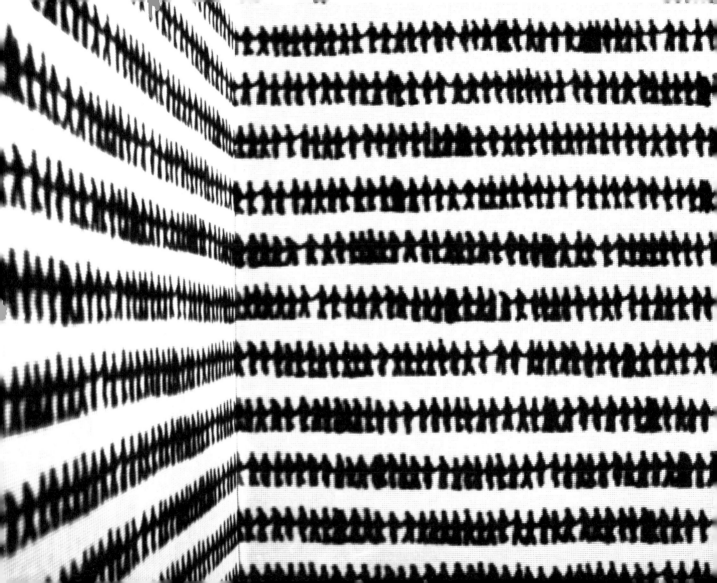

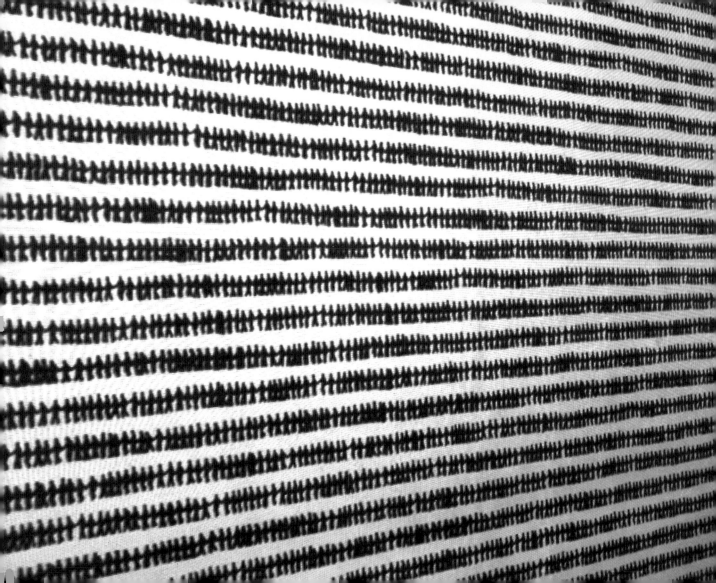

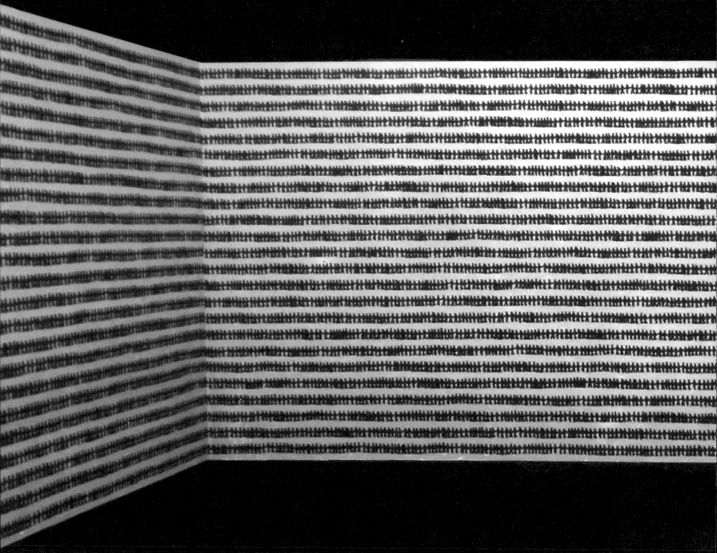

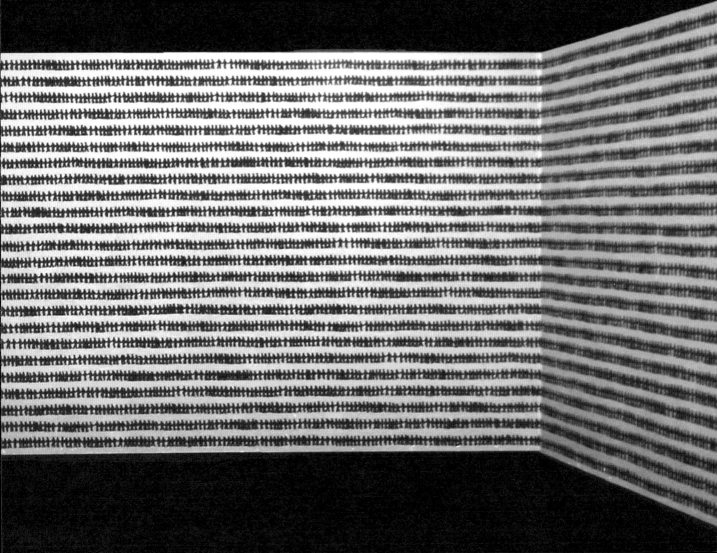

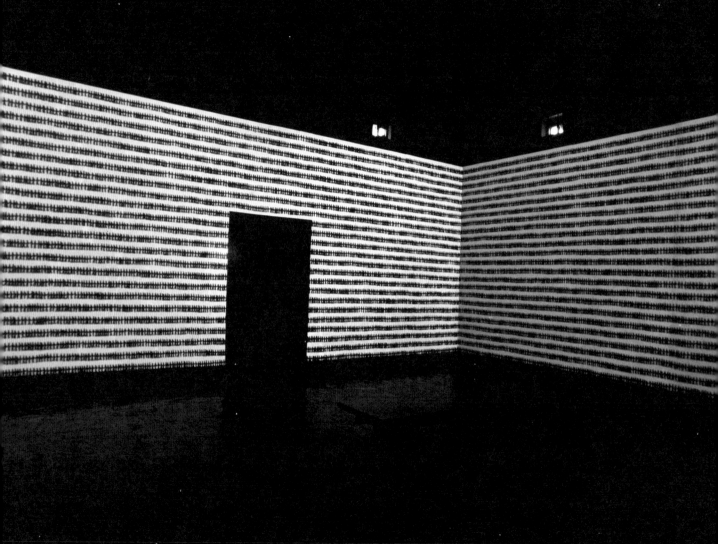

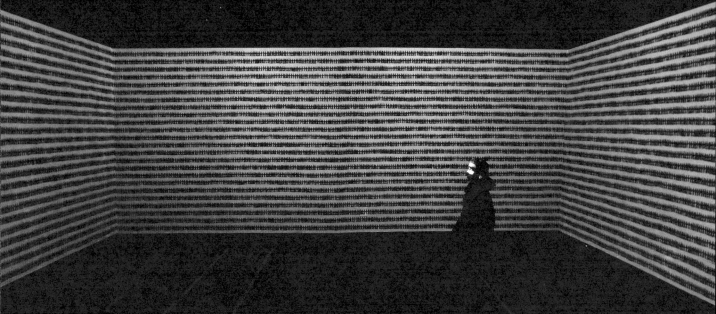

FIELDS OF FIRE

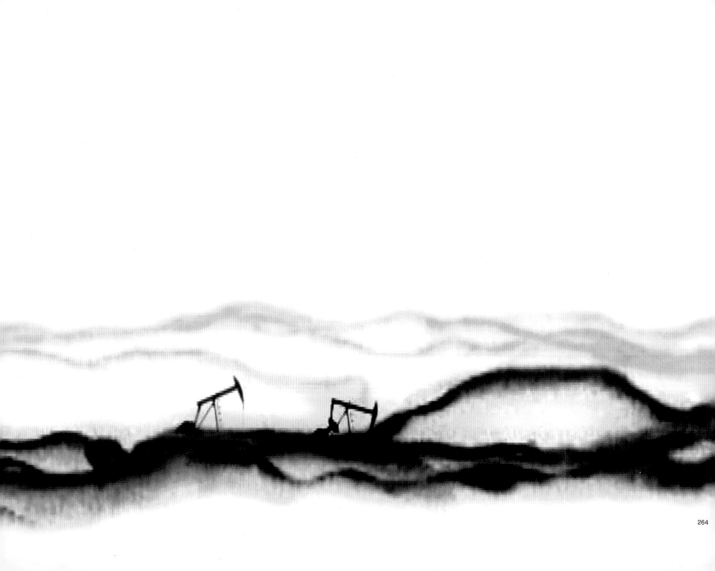

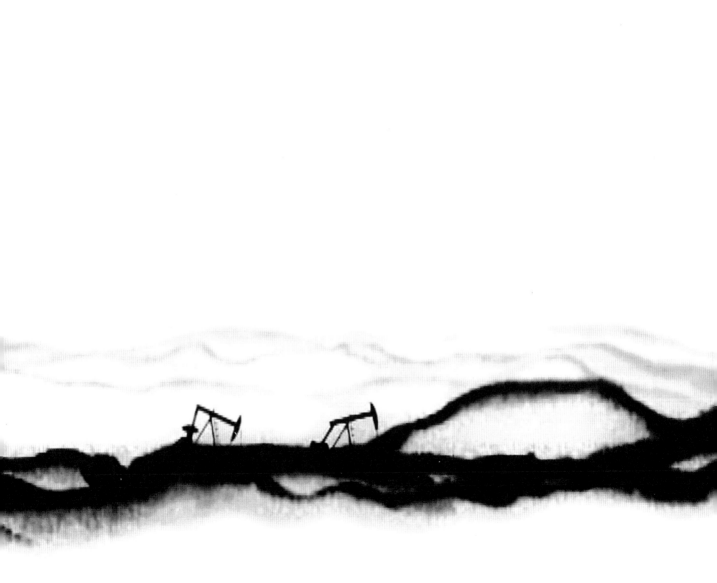

272

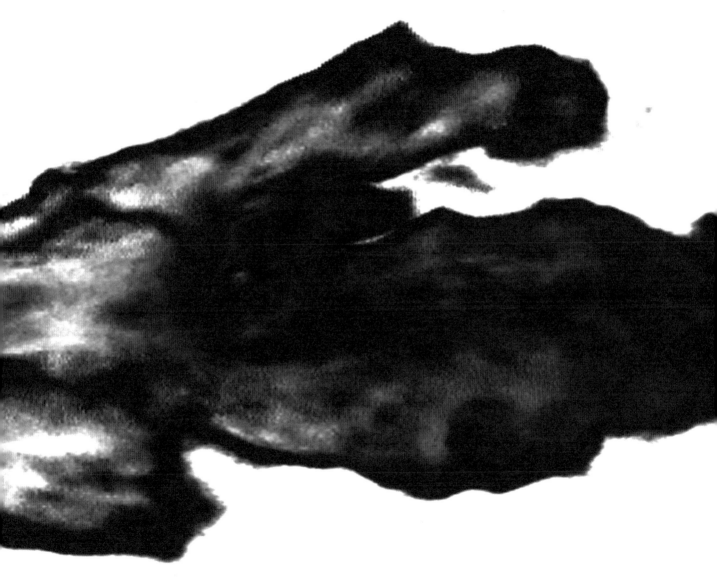

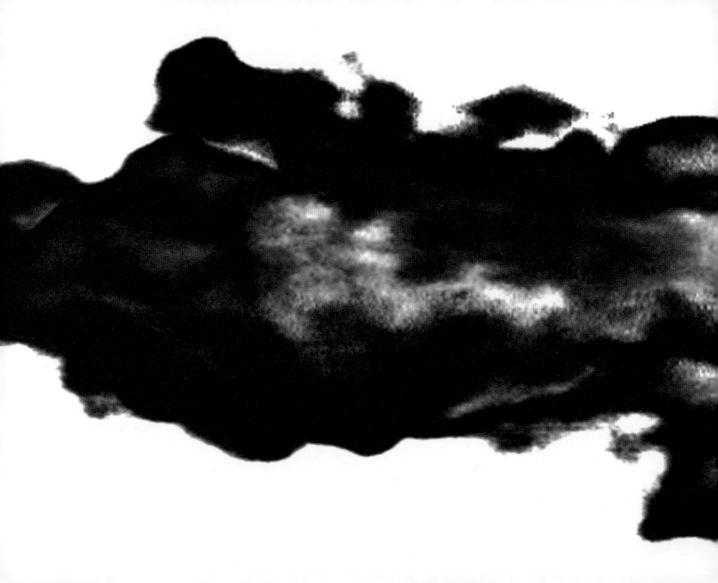

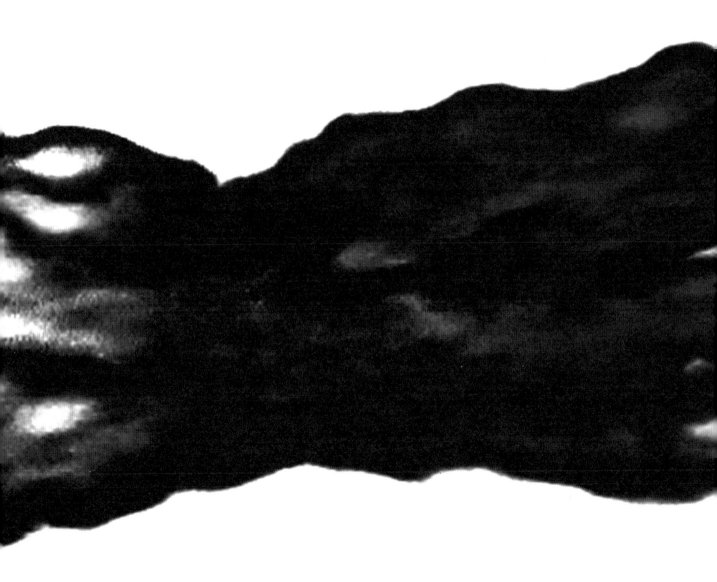

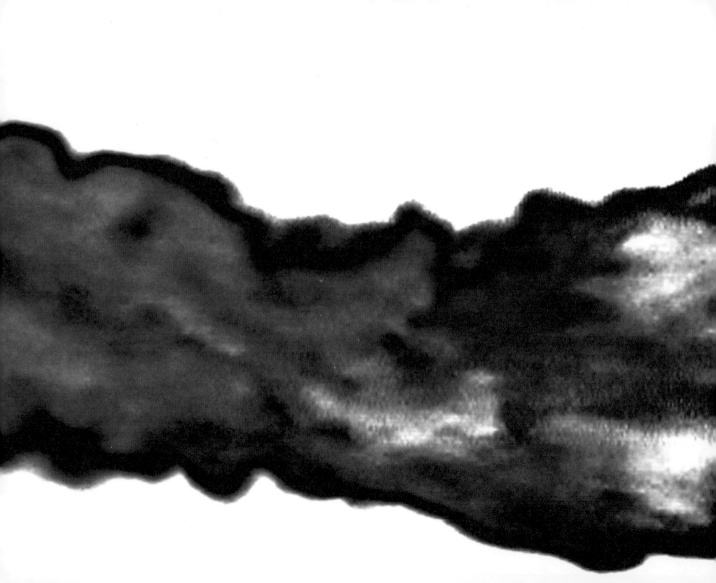

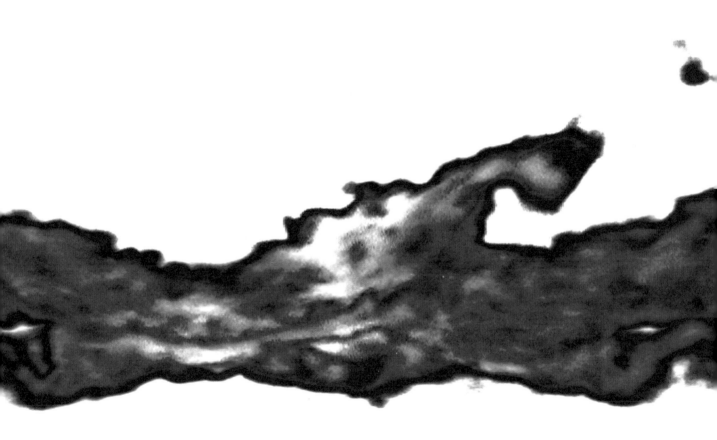

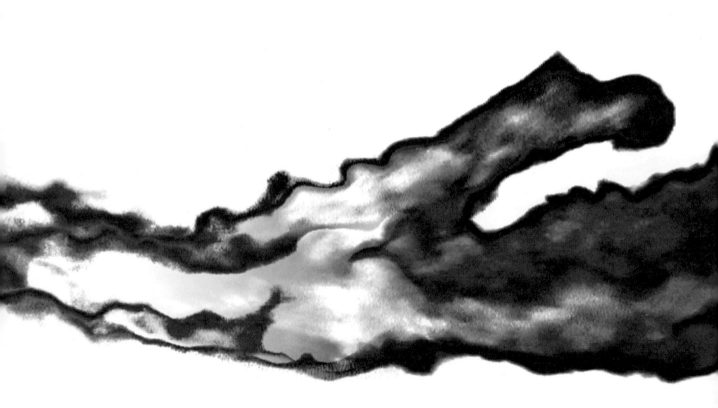

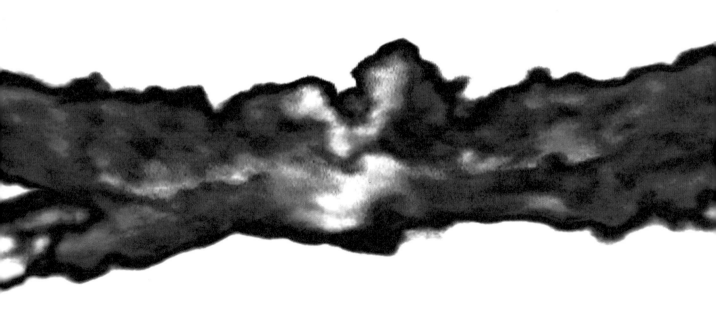

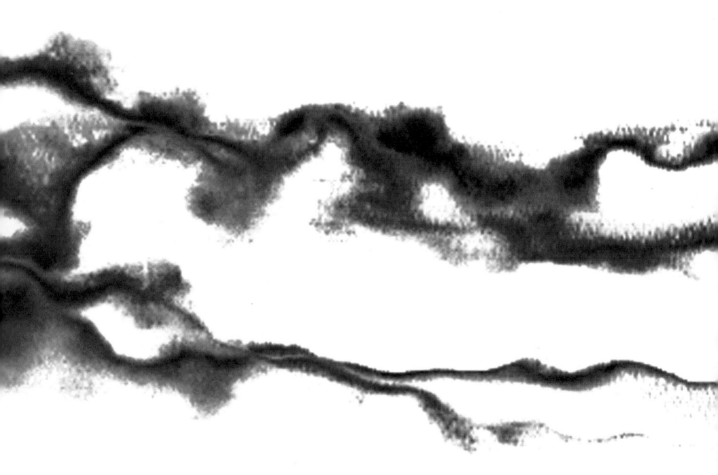

288

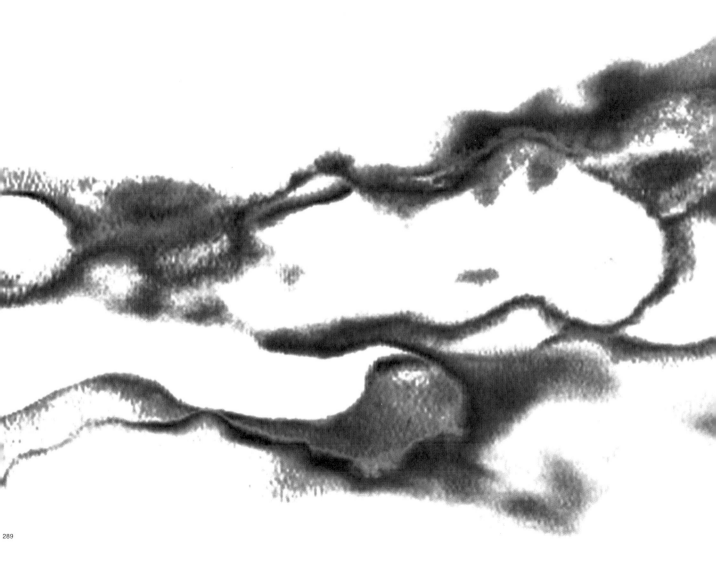

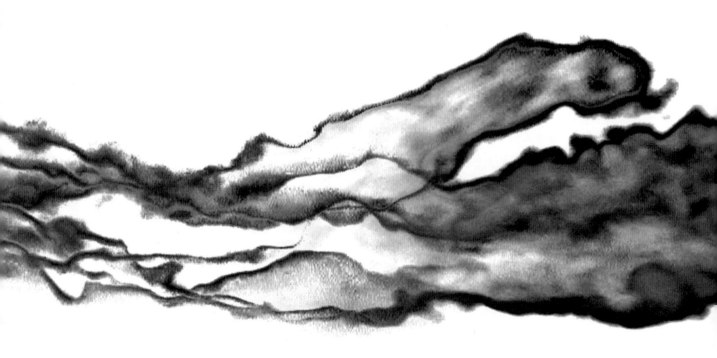

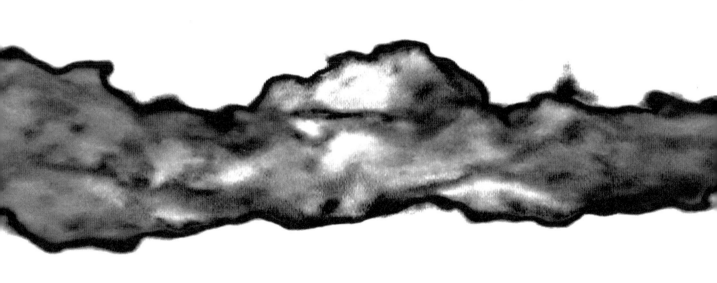

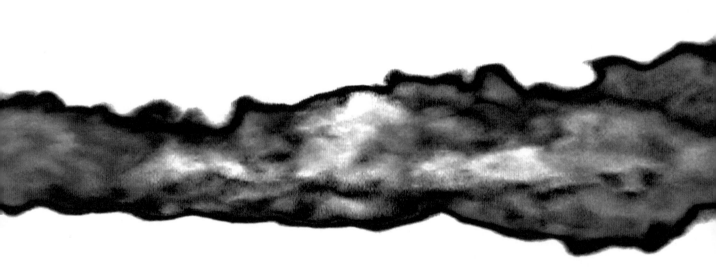

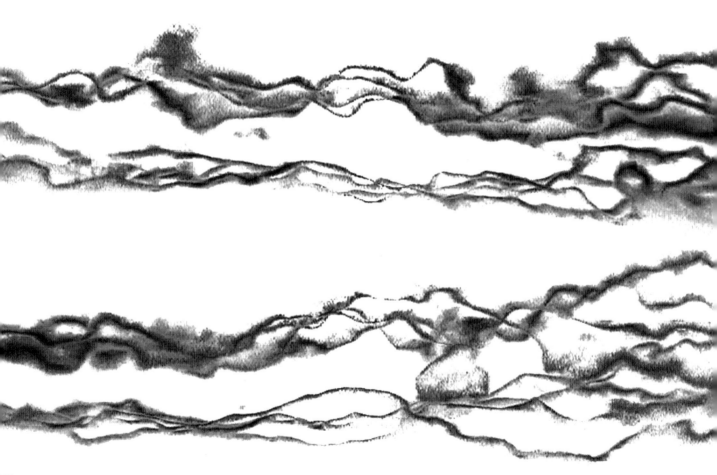

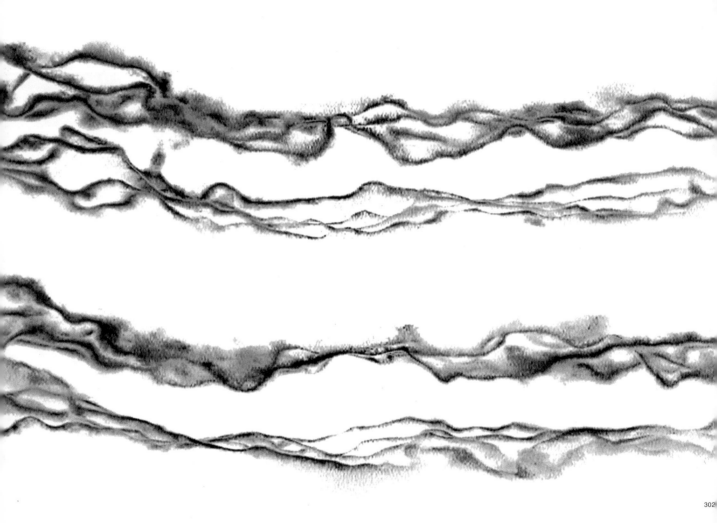

302

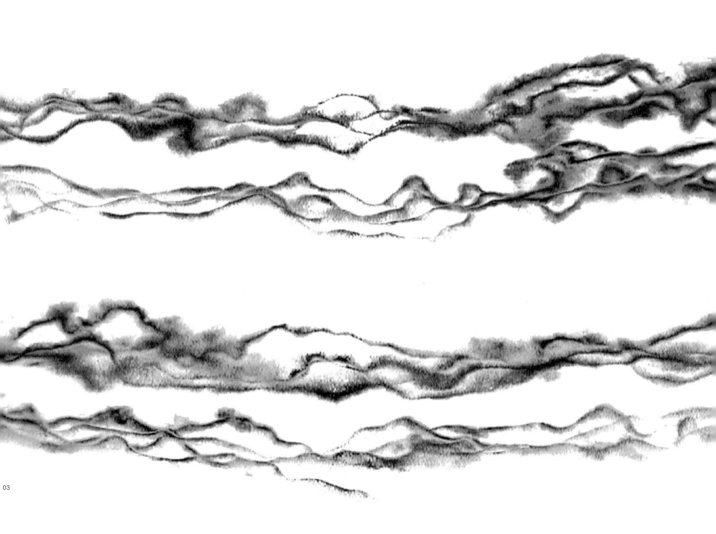

03

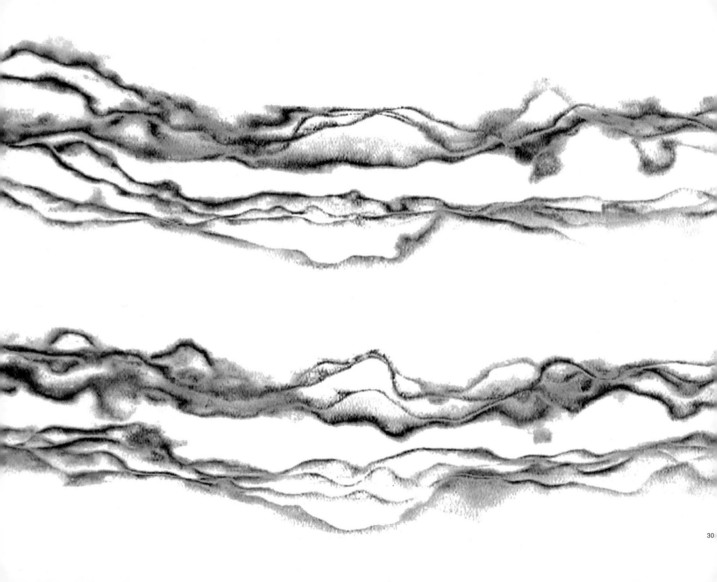

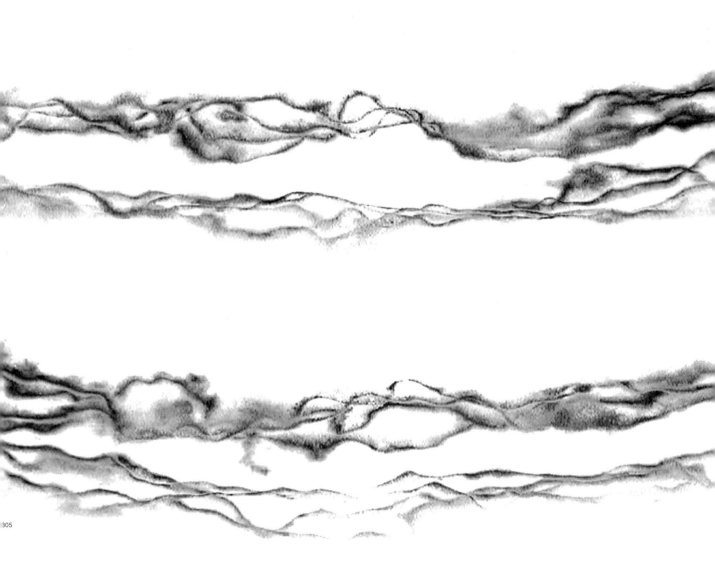

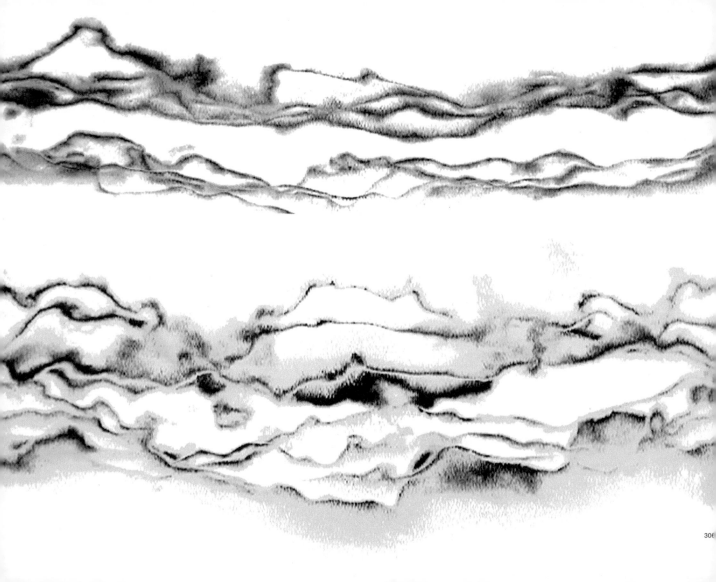

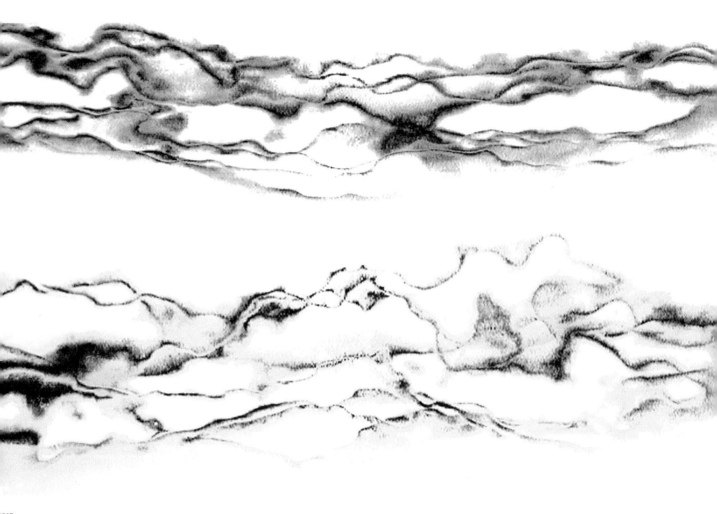

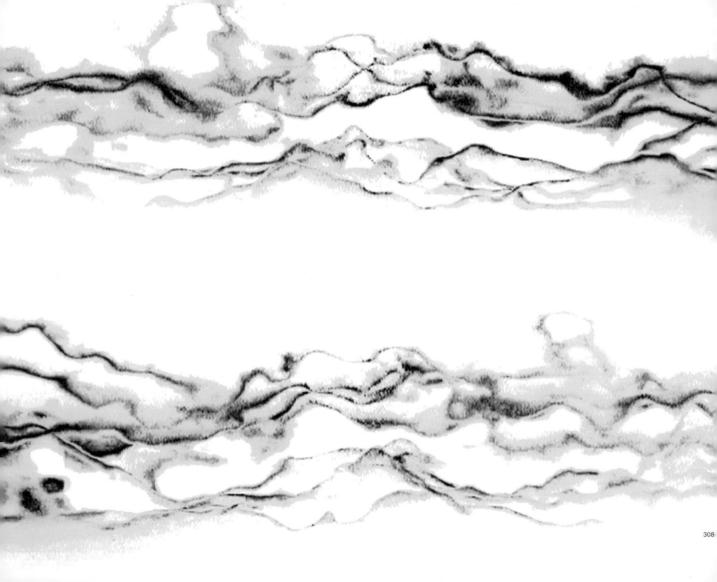

308

צ. לוצים

FEB 2004

שלוש נשאברתי

Lines Moving

(feel like in)

||||| ||| |||

||||| ||| |||

||||||||||||||

||||||||||

Far → closer

314

אולם - /אוני - / אסור (ואין)

‏— עלוי, סיר, חיית, עלוי, שלאי

MICHAL ROVNER, EXPERIENCE AND SPACE

Sleep lingers all our lifetime about our eyes, as night hovers all day
in the boughs of the fir-tree. All things swim and glitter.
Our life is not so much threatened as our perception.
Ghostlike we glide through nature, and should not know our place again.

Ralph Waldo Emerson, *Experience*

The unconscious abides.

Gaston Bachelard

The first work of Michal Rovner's that I saw was a photograph from the *Outside* series – the famous house in the desert, in a version which shows it off-centre and at an angle, a dark apparition against a blurred, grainy background, as if caught in a sandstorm (probably *Outside* # 1, 1990-91). Then, a little while later, I saw another one, with a human shadow against the same kind of background, from the series *One-Person Game Against Nature* (1992). I thought a lot about those two images. Then, when I was better informed, I had the idea of

inviting the artist to exhibit at the Centre national de la photographie, where I was about to become director. She seemed rather reluctant at the prospect of her work being too closely associated with the world of photography. And so things stood for about ten years.

She was right, of course, as can be seen from the path she has taken since then (even if the Centre national de la photographie itself moved in the same direction during those years, with artists who took an open approach to the medium).

However, what I found compelling in those two images was very much the result of an original and (for me) enigmatic

use of the medium, suffused with a very potent thematic dimension (the house, the desert, shadows). And, ten years later, with a fuller idea of this important and protean body of work, what I still find striking is that mixture of technical invention with the ability to deploy powerful archetypes. But let me try to describe all this a bit more precisely.

Michal Rovner is no more able to bypass the logic of the medium (or the mediums) she works in than any other artist. Mediums have their histories and their laws, their own dynamic, and the artist plays on these dialectically, alternating between proximity and distance, perverting and regenerating them. Her first photographs were the result of multiple manipulations (Polaroid prints were rephotographed, enlarged and coloured), just as her current video installations involve complex digital processes. The starting point is a core, a piece of the real that is either taken as found or presented in a certain way (a house, a place, a row of figures, a flame, etc.). This image is then subjected to numerous operations that profoundly transform its scale, texture and colour, so that the resulting entity does not belong to a given space or order of representation but seems instead to exist autonomously, as if the work created its own rules and references. The material of the photographs has a quality that is at once painterly and cinematographic, while the videos bring to mind animated drawings, or experimental cinema. But these analogies do not get us very far when it comes to describing the presence of these works, the way they institute a specific space. For while they are indeed "installations", this is not just in the sense of belonging to the rather hold-all category that was originally meant to accommodate what Rosalind Krauss called "sculpture in the expanded field", but in the more active sense, that of inventing a specific space, a space that is simultaneously perceptual and symbolic. We therefore need to consider what it is that might constitute Rovner's "central region", the "logical space" of which individual works would be simply avatars or approximations.[1]

To come back to the initial example, the theme of the house is a very rich one both symbolically and conceptually, as is that of the human silhouettes and chains that appear in many of the videos. Indeed, some commentators have constructed thematic readings of the apparent contents of Rovner's work: the house, the desert, flight, the flame, etc. These have their interest, but are a long way from the kind of philosophical dimension in which Bachelard took such elements beyond placid thematic nomenclature.

Perhaps one way of attempting to define the notion of space in Rovner's work is to think in terms of a related approach (one that no doubt owes a great deal to Bachelard). In an essay entitled "Turning Point and Revolution – A Discourse on the Heideggerian Idea of Movement", Peter Sloterdijk distinguishes three moments, "three universal, impassable mobilities which anticipate everything else, three kinetic

traits – fall, experience and reversal – that, in life, always have different effects, that take all the institutions of civilisation, including their metaphysical foundations, by surprise."[2]

I will dwell for a moment on the notion of experience, insofar as I think this sheds some light on Rovner's work. This idea came to me when I saw the film she made for the new Holocaust History Museum at Yad Vashem, a piece which, I think, can allow us to reread some of her earlier work. This film comprises a complex assemblage of images and sounds found in European archives, and bearing on the life of Jewish communities before the Holocaust. These documents, some of them mere fragments – a few seconds of film, sometimes just a single image – were digitally reworked, duplicated, assembled and over layered to form an ensemble of about eleven minutes, which flows slowly before us like the flux of memory. The visual but also mental and physical space thus constructed is informed by a very singular temporality which brings into play a number of contradictory pairings such as the long time of history and consciousness in and of the present, slowness and condensation, insouciance and premonition, continuity and discontinuity, homogeneity and heterogeneity. We are confronted here with a space-time that is close to dream, but that leaves each viewer free to appropriate it, to constitute and project their own memories onto it. It is not a closed space, a refuge-space, but an open space, one that flows from the movement of the images itself. It is the montage,

arrangement and flow of images that constitute it, and that constantly create and uncreate a spatial and temporal depth that is entirely a construction.

In fact, nearly all Rovner's works have this kind of development, whether the movement that engenders their inner space takes the form of walking, flight, repetition, camera movement or editing. Theirs is a migrant space, apparently random but in fact subtly calculated, open onto the events between things (and here we can see how inappropriate it would be to compare Rovner's works with those, say, of Shirin Neshat, with their rigid dichotomies, their tightly-drawn dramatic-narrative quality – not that this does not have its beauty: that is not the issue) towards a kind of *climax*.

Peter Sloterdijk has written as follows of this Heideggerian movement between fall and reversal: "Being-there, in the second mode of mobility, thus signifies installation and exodus, a taking possession of a land, and migration, trajectory and curriculum. The quintessence of this mobility goes by the name of experience."[3]

There is no need to insist on the many differences between the conception of space and movement formulated by the Catholic peasant-philosopher who dreamed of Germany becoming a new Greece, and that of the rooted-rootless Jew Michal Rovner who, to use Walter Benjamin's terms, inhabits a temporal constellation where memory is mixed with expectancy. What she is attached to is not a place, it is a com-

plex space that sometimes seems to materialise, but which always bears the mark of loss. A space that is situated – if this can mean something – between installation and exodus, form and dissolution, memory and forgetting. Not a "central region," then, unless we take this term in the sense given to it by Michael Snow in his famous film of the same name: that is to say, the place of the apparatus itself, that of the vision machine.

But Rovner's work is a long way from the conceptual austerity and irony of those artists and theoreticians who, in the 1960s and 70s, tirelessly probed the question of the apparatus and its complex relation to the viewer. Rovner has taken on board the contemporary condition of the spectator (after Modernism). Her concern is not with the tricks and aporias of a theoretical place, but more with the fields in which that place is engaged – the fields of energy, fields of consciousness, the aural and visual fields that surround it, as can be seen in her most recent piece, *Fields of Fire*, for which Heiner Goebbels did the sound. How is a source image, a fragment sampled from the continuum of the real, able to proliferate, to mutate and, like a living organism, like a stem cell, to engender other configurations, saturating a space by its continuous variations or, on the contrary, causing extreme rarefaction? These are the questions, and the emergence, that Rovner's works invite us to consider.

Régis Durand
Translated by Charles Penwarden

1 Cf. the essay by Rosalind Krauss, "Sculpture in the Expanded Field" (1978), *The Originality of the Avant-Garde and Other Modernist Myths*. Cambridge: The MIT Press, 1988: "For, within the situation of postmodernism, practice is not defined in relation to a given medium – sculpture – but rather in relation to logical operations on a set of cultural terms, for which any medium – photography, books, lines on walls, mirrors, or sculpture itself – might be used [...] It follows, then, that within any one of the positions generated by the given logical space, many different mediums might be employed. It follows as well that any single artist might occupy, successively, any one of the positions" (pp. 288-289).

2 Peter Sloterdijk, "Tournant et Révolution – Discours sur la pensée heideggérienne du mouvement," *Essai d'intoxication volontaire*, followed by *L'Heure du crime et le Temps de l'œuvre d'art*. Paris: Hachette Littératures, 2001, p. 297. The original title of the book in which this essay was published is *Nicht gerettet. Versuche nach Heidegger*. Frankfurt am Main: Suhrkamp Verlag, 2000.

3 Sloterdijk, op. cit., p. 307.

BORDERLINES

Borders don't border anything, they hardly manage to border themselves. The more they try to, the more they fail, eventually growing exponentially at the expense of what they were supposed to protect. No border can safely enclose a country, or anything for that matter, without throwing it into some kind of borderline state.

Michal Rovner has always been interested in borders, body borders, individual borders, national borders – any border. In 1996 she decided to address the question through the lenses of the Israel-Lebanon conflict. It was a conceptual intervention in political grounds, but no less conceptual for that. She hung forty-two banners above the electric fence, with an X printed on each instead of national flags (*Dilemma: The Good Fence,* 1996). By doing this she was negating the very purpose of a border, which is to keep different entities separate. Seen from both sides, the X brought them together instead of dividing them. Suddenly the border became an unknown factor in an all-too-well-known equation, a question raised to the notion of territorial rights, and more generally of identity. Could differences be made inclusive instead of exclusive? Why not display common features that would coexist peacefully? And yet if a fence is meant to keep one's neighbors away, could there be such a thing as a "*good* fence"? (The Israeli army had chosen this name in the hope of attract-

ing Lebanese people to the border). It was, of course, an absurdist proposition, like Kafka's Great Wall of China, mostly made of holes. Israel already had many fences, everywhere, so there was no need to have an additional one at the border, even a "good" one. It was while creating *Dilemma* that Rovner started making a fictional video about the border (previously she merely used video camera to capture still pictures). She called it *Border*. It took her over a year to complete. From then on video became her major tool. The present exhibition gathers most of the videos she made during this last period, from *Border* to *Fields of Fire* (2005), which has never been shown before.

The shift from stills to motion pictures opened up many possibilities that she was quick to exploit in ways that extended drastically what had been conceived until then. One never knows what one is capable of until an encounter, an accident or an opportunity puts you on a different track. Rovner may not have thought it possible that one day she would make stones move, letters dance on notebooks, tiny dervishes twirl at the bottom of Petri dishes, miniscule multitudes crawl all over the room, or huge flames lick the wall of a museum. In the last eight years, with a dizzying speed and freshness of invention, she managed to turn video into a challenging artistic medium, recasting along the way all the other arts, and blurring the limits between art, philosophy and science.

Rovner was born in Israel, a country at war with itself as well as with its neighbors, and this has certainly left a deep imprint on her sensibility. She has gone through four wars in her lifetime, including the Gulf War in which Israel wasn't directly involved, but was under fire. The Israel-Lebanon conflict finally ended in 2000 with the withdrawal of the Israeli army from Southern Lebanon. The war didn't stop for all that, only moved inwards and took on horrific features with the beginning of the Intifada. Only an artist born in a country at war could be so obsessed with borders, and dream of abolishing them. And yet war is not the key to her work. Nor is the Holocaust for that matter, although the recent installation she made for Yad Vashem, the Holocaust Museum in Israel (*Living Landscape*, 2005) would seem to allow for that connection. Nothing in her work can be interpreted in a simple way. Rovner is first and foremost an artist, and this has always taken precedence. She deliberately keeps some distance from any issue in order to achieve artistic clarity and spiritual strength. "I'm not interested in memory that has to do with remembering," she said, "but more with the residue of things, the left-over of things on the mind – not with something that's occurred, but with the mark that is left. It's about stripping down the image to its most essential elements."[1]

Rovner's work has to do with stripping down the present, not mourning the past. She is all-too-aware that one cannot take anything at face value. She knows that the present is

never given, and that it takes a lot of courage and determination to reclaim it. From the time Rovner was in school, and graduated from the Bezalel Academy of Art in Jerusalem in 1985, she resisted seeing what she *had* to see or receiving what she knew she would forever *owe*. One couldn't even begin to understand her itinerary if one ignored the intensity of this refusal. Art became a way of reclaiming her life. Trained in photography, she threw away what she had been taught and insisted on making "bad" photographs, choosing uninteresting subjects, making blurred, faded images, devoid of contrast or focus. She was competing with nature, using photography as a means of transport, creating borderless shapes geared toward further dislocations.

Blurring the picture, rephotographing and manipulating it in her studio, was a way of seeing more clearly what happened in-between things. What matters is not what things are in themselves, but what they leave out. When Kafka looked at passers-by in the street, it was the space between them that he was looking at, not the persons themselves. It takes a certain kind of disinterested look, disregarding what is considered meaningful and significant for what appears residual, negligible. Rovner was experimenting on her own, just trying things for herself, deliberately staying *out-of-focus*. For months she photographed the farm she had just moved to, on top of a field of artichokes that she cultivates, because it looked bland and unfinished. Then she spent two years pho-

tographing an isolated Bedouin house she found by the Dead Sea, because it had no door or windows. She wasn't interested in interiors or in any sort of depth. She acted as if these houses had none and merely skimmed the surface (*Outside*, 1990). Playing with light, adding colors, creating atmospheres, inducing speed in different ways (shaking the camera), she discovered something important about the nature of reality. Things or people don't have any particular essence, they are created each time anew by putting various elements together in different ways. It wasn't the same Bedouin house when fog, night, wind invested it with mystery, fear, terror – bringing out its *diabolical* powers, windows glaring in the dark – or made it vanish altogether in the distance. There was no such thing as a fixed object or identity. No contour or border was ever set. Reality was up for grabs. Stripping human contours of unnecessary details, isolating them from any ground and blurring their shapes, she was able to achieve a kind of *abstract materiality*, unifying elements ordinarily conceived as separate, even irreconcilable. All it took was to identify a common feature that would transport them to another body.

But it was the metamorphosis that counted, not the similarity. It was like an experiment, changing the nature of reality as one changes time zones. *Étant donné...* Given that a man raises his arms: 1) he floats; 2) he flies; 3) he surrenders; 4) he waves, etc.. Something can be what it is and become something else given another context. And the context in turn

changes as well because that gesture turns the sea into the sky, water into air. Everything can be related to other things and be affected by them in return. Rovner was restoring nature its fundamental unity and fluidity. Nature knew no border, being *borderline* itself.

Bodies floating on the Dead Sea open their arms and fly in the sky. Heads walk on legs in photographs taken from the roof. Shot from the back, workers hunched over on a hill change into a herd of deer or horses, a flock of herons, a string of teeth, or chromosomes [*Tell (Hill), 1995*]. Bodies fly in water, swim in the air or float on a desert. They fold and stretch and shrink, become different creatures. This is the way species are being created everyday out of each other, everything laid flat on the drafting table, nature at work, constantly trying out new compositions. At bottom there is only one animal, every difference merely comes "from another arrangement, a complication, a modification of what essentially remains a unique plan."[2] Rovner subjected her farm and the Bedouin house to continuous *topological* deformations by merely moving them to a series of neighboring zones. War zones, twilight zones, desert zones, data zones. Unusual postures or unexpected angles were enough to trigger new configurations, strip them of their gender, species or identity. It sent them packing, mutant forms looking for a perch.

It took nature hundreds of millions of years to evolve an incredible array of living creatures, great and small, but devolu-tion is happening everyday. At every moment elements are loosening up from their moorings and drifting in concert to some unknown destination. *Everything is ready to go*, all it takes is a little nudge. A blurred human form crawling on a bright red ground becomes a tapir, a dinosaur, a wounded deer, a dog, a lizard, a dying creature, each eliciting different emotional reactions from the viewer (*Red Fields*, 1995). "What is a body capable of?" Spinoza asked. Instead of looking for what a body is in itself, one may rather look for some energy that would tip the balance, or an encounter that would reshuffle differently the relation between various parts. Everything in nature is "material" in the ontological sense, a pure potentiality that can be actualized and modified in unpredictable ways. Everything results from different arrangements of the same substance that belongs to a single plane. "One substance for all the attributes" is Spinoza's first principle. One doesn't need to read his *Ethics* to become a Spinozist.

In *Border*, Rovner intended to investigate *a* border, not just *that* border. But one can only question something when engaged in a real situation. This made her project all the more interesting politically, even if she didn't mean it to be political. *Border* deals with territorial claims. But what are territories? A composition of parts that vary according to their numbers, situation, their mutual dependency. It is always possible to break down some material and put it together differently. The Israeli General chaperoning Rovner along the border was

overseeing both sides, not just one. "Take me to Lebanon then", Rovner said in the video. "Impossible", he replied. One doesn't cross an enemy border. But how much of a border is a border? Except for the fences, it was the same landscape on both sides. Where did a border start, and where did it end? Actually what was *not* the border? Throughout the video the General kept calling on her cell phone from Lebanon in an Israeli convoy. Didn't that fact prove her point? Art and the Army, a most unlikely couple, each claiming authorship on the situation. The man's job was to maintain the border, hers to demonstrate that it was improbable, making the border borderline, ultimately turning it into her own artwork. The border was a fiction that both sides mutually agreed to take for real.

And yet the fiction of a border had to be maintained, turned into a reality.

Every so often the camera feverishly tracked the rocks looking for eventual snipers. They could start firing anytime. The General evoked death lurching around, some of his men killed over the hills. The border wasn't real, but living at the border was. Only a fiction could give it a form, being a fiction of the same order. Suddenly something blew up close by, smoke rose, someone shrieked in pain, bodies laid under the jeep. A mine had just exploded on the road nearby. Was the fiction real after all?

Border dealt with conflicting viewpoints, territorial disorientation. But a more deterritorialized reality was present as well. A helicopter was flying overhead, birds moved in flocks. It was flocks that counted, not individual birds. And yet flocks became different from each other whenever they entered specific zones. The first flock shown in *Border* crowded the entire sky, thousands of tiny blurred specks hovering in the distance, changing colors and consistency, turning ever more abstract in the light. Eventually they rose vertically in the sky on an updraft, like so many tiny crosses. And yet flying in slow motion, they looked hardly different from bombers in formation. *Border* is 48 minutes long and two years in the making, but it took Rovner only a week to put together a short video (*Mutual Interest,* 1997, 5 minutes) out of the same material. The rapidity is indicative of the transformation that occurred between the two, turning humans into birds and birds into bombers. The new video started with ominous looking shapes sneaking through gray clouds accompanied by the dull drone of a bomber's engine. They crossed a delicate net made of myriads of birds floating in the sky. Suddenly a shot was fired, then a machine-gun and a panic of black wings rushed through the screen from left to right. It was violently met by a tight formation of bomber-looking birds coming from the right, and a quick fight ensued. The myriad of other birds, unheeded, kept gliding like a scarf over the sky, their choreography so exquisite that it even managed to eclipse the brutality of the action. Their absence of reaction paralleled the birds' indifference to the bomb explosion at the end of *Border*.

And yet there was something deeply fascinating about hundreds of birds breathing in and out together like a huge cosmic lung in the sky. The metamorphoses Rovner had painstakingly orchestrated in her photographs the preceding years, blurring the bodies' contours, moving them through different zones (air, earth, water, fire), shifting them through ever changing configurations, were accomplished effortlessly by these birds, without a stop, like a dance. Nature itself was *materializing abstraction*. All that was left for her to do was abstract that material. And this is what she did. Over the next two years, as a spin-off to her videos, she made several series of still images,[3] flocks of birds distorted by motion, speed or distance, barely identifiable. Crowds of delicate smudges covering the entire canvas. Abstract painting, ecstatic visions. Eden must have been an aviary.

It was unlike anything Rovner had done before. It had been *the wrong way around too,* starting from individual features (limbs, postures, etc.) and not from the ensembles themselves, as she was doing now. There was no need anymore to question borders, even look "in-between" things. In-between was everywhere. Starting with fluid configurations, nothing was left out. Blurs were no longer necessary. Everything was "transported" without having to move. Reality was everywhere. It was pure "transformism." The series of abstract photographs she made on canvas and on wax-paper in 1998 had no title and didn't need any. She was doing on paper what

myriads of birds were tracing in the sky. It was as if past a certain threshold the fascination with multiplicities *as such* had taken over. It began working on its own, proliferating in unpredictable ways, ultimately delivering something unsettling and wild: a "psychotic landscape."

* *

"Individuals" are rare in Rovner's work. They want to keep separate what belongs together, insisting on maintaining definite borders. Bodies, like borders, are porous to the outside. Rovner's blurred creatures have been likened to Giacometti's anorexic sculptures, but that entirely missed the point. It is *surface movements* that fascinate her, not angst and unfathomable depths. Individuals resist the flow. In *Coexistence 1,* 1995, two tense dark figures are walking away from each other on opposite edges of a cliff, heads bent. Obviously, they have no intention to share the same space. (The political implications are clear). Would a group be an alternative? Rovner addressed the issue in a series of photographs called *Merging* (1997), documenting several attempts at metamorphosis within a group. Another protocol for an experiment: given that four men are standing apart from each other... *Labyrinth,* 1997, shows their rigid silhouettes, slightly tilted, mirroring each other from both sides of the photograph. Would reversibility help them interact? In *Merging in the Wind*, a group

of ghostly figures is standing to attention, head down. The wind is blowing through them, leaving empty streaks on their bodies. Would the wind manage to loosen them up? In *Blur* (1998), on the other hand, a few faint silhouettes are slipping away at the end of a pale yellow field. Only shades of their bodies are visible, energy caught in a few powerful strokes, a vivid portrait of a metamorphosis. "You're always watching something," Rovner said, "but half of it is not there." *Merging* also provides a final counter-proof: a blurred group of jocks standing like a big blob on a yellow ground, their heads all but erased. They tried to merge, and the result is ugly, a precarious assemblage of mismatching parts. Groups don't think, *ergo* they block transformations. The two series of photographs, one chronicling the birds' radiant transformations in flight, the other the breakdown of shaky individual borders, were developed in parallel from 1997 to 1999.[4]

"Groups," Rovner commented, "don't always make people stronger. They are just one big mass."

Most theorists of crowds at the turn of the last century saw them in that light and feared their potential for violence. Individuals in a group, they asserted, regressed to an inferior stage characterized by suggestibility and irrational behavior. A group could only be contained if it behaved like a big individual, all it took was a leader-father-fuehrer figure to whom they could identify. What came out of that we know all too well. Elias Canetti, Nobel Prize winner and author of *Crowds and Power*, thought otherwise. Individuals, he suggested, keep apart because they fear contact. Only a crowd is capable of releasing this "burden of distance," the individuals' anxiety.[5] It was this "discharge" that made the crowd into a crowd. Equality, not hierarchy, was the crowd's main attribute. While groups strive to erect new borders around themselves, multiplying tensions inside, crowds are made of *multiplied individuals* engaged in fluid and changeable configurations. Individual differences were not important, only what circulated "in-between" people whenever they acted together. It allowed for their energy to flow, just like flocks of birds.

Specialists recently acknowledged that, contrary to previous assumptions, birds were highly intelligent. "A French group from the CNRS (Centre national de la Recherche scientifique) taping heart-monitors to birds' backs found that their heart-rates were lower when they flew in formation. They could fly farther and glide more often, staying in the 'slipstream' of the bird ahead. *Pattern-flying saved energy*. It also allowed them to communicate with each other on the wing." Save energy? Birds kept spending more than they had, just for the beauty of it. The more in touch with each other, slipstreaming, the more one with the universe. All it took was communicating "by the wing."

Humans use words to communicate and coordinate their actions. But words don't fly, they are overloaded with meaning. How can one manage to take words "by the wing"? Just

before doing *Time Left* (2002-03), Rovner got very interested in the notions of text, signal, sign, the visual appearance of language; marks that people make, or leave behind. It didn't matter to her what the messages actually meant, only the bare act of communicating. (Her father was a radio ham). Like frescoes, texts are visual things. She decided she would use human bodies as a text and traveled all the way to Russia and Rumania to videotape silhouettes profiled on top of a hill on an empty sky. (She insisted on shooting her material on location although nothing of the original details remained after the final edit. The celebrated eccentric French writer, Raymond Roussel, similarly insisted on travelling throughout Europe in his limousine with its window-blinds down. The more abstracted the material, the more grounded in an original it must be). The silhouettes were holding hands. It was the first step beyond individual isolation.

Rovner was still unsure about the size of her wallpaper people. Would she make them big or small? She wanted the look of a history book, so she finally decided to reduce them. She ended up with hundreds of minute men, actually a mere dozen of them replicated ad infinitum. In *Time Left* one could see them from floor to ceiling walking slowly along scores of parallel lines, like a moving musical score. Catalepsie ambulatoire. A continuous flow of little black figures progressing seamlessly, without a break, holding hands, or chained together, humanity on the march. Were they coming or going?

Impossible to tell. There was no before or after, no time left behind. Progression was repetition. Time stood still.

And yet focusing too much on the procession itself would be missing what turned out to be the major point of this installation: the astonishing reduction of scale. It is at this point that the mutation occurred. A group differs from a crowd in terms of numbers. Diminution was a quantum leap into a *qualitatively* different universe. The multiple doesn't just express itself through motion, it involves a reduction in size. Crowds only become crowds when seen from a distance or from above, as one looks at insects, rodents, animalcules of all kinds crawling at one's feet or on one's body, like Gulliver. Actually any reduction in size suffices to create an effect of distance. One simultaneously perceives a large number of diminutive creatures. Numbers only appear as such when the scale is reduced. Little men are not just big men made small, they cease to be individuals, or even humans. They turn into caterpillars, a procession of ants, a continuous flux of data, pure lines of energy.

Not every large thing can be diminished in order to enter this small world. Viewers, for one, can't be sized down. What they perceive also varies with the distance. From afar, all one can see is some kind of hatching, thousands of little sticks crossed over, like counted units. And what a strange accounting it is, each bundle of sticks being somehow *subtracted* from the rest. Sinister reminder. Closer on, the mass of tiny people is overwhelming, as if seen through some kind of

magnifying glass. More disconcerting yet is that these manikins are projected *on a large scale*, covering entire walls like frescoes. There was no need to "transport" them anywhere else, or blur their contours. Now it was the viewers themselves who were only "half there."

All the installations that Rovner created over the last few years involve some kind of visual oxymoron, starting with the clash between antiquity and present time. The old well on display in *The Well* (2004) seemed a bit incongruous on the floor of a modern gallery, but it was an authentic well covered with moss (Rovner found it in France). For centuries, wells had been a major communal element and its symbolism was still alive. Looking down was like going back to the source of life, digging through another layer of reality. The well was a huge telescope in which the viewers could peep at the past. At the bottom, though, was a blue monitor displaying something unexpected, a pack of tiny creatures madly running around and around, as if caught in the drain. This is what happened when individuals in a group each go their own way, refusing to interact with the others – the configuration implodes. It was imploding in a twirl like a tiny comet at the bottom of the well, in the sky down below. The frantic little men turned red, the space around them congealing into a sickening blood paste. Chaos and blood were at the core of this protected oasis as they were at the source of any social contract. The primal scene, if it existed, would be a crime.

Another installation (*Data Zone*, 2003) expanded this concept further. Instead of a big circular well, a number of small white Petri dishes were fitted in a long table, glowing in the dark like so many tiny monitors, which they were. Bending over the culture plates, visitors discovered again, crowding the bottom, instead of tiny micro-organisms, another group of diminutive men shot from above from what seemed to be a huge distance. Their features were highly defined instead of blurred and it was difficult to resist the feeling that these puny people were actually there, moving under the glass. A jerky bunch, to be sure, caught in abrupt kaleidoscopic changes, each twist triggering different kinds of configurations, alternatively jolly and sinister. In the first, the creatures were carried away on a centrifugal wave, their formal attire, top hat and black coat, in comic contrast with their hectic pace. As their speed increased further, they turned into tiny leaves swept away by a powerful storm. Alternatively, they held each other boisterously in a dance, or paraded with zealous zest in fanatical formations, their bodies lined up in what looked like crosses and swastikas, but also spiders, caterpillars, hairy chromosomes, or monstrous centipedes digesting themselves through twisted coils. Constantly crossing the border between the human and inhuman, the grotesque and the horrible, they were fascinating to watch in spite of the repulsion they inspired. Philosopher Jean Baudrillard, who saw them at the 2003 Biennale, called them: "strange attrac-

tors," a term borrowed from mathematics.[6] "I only find interesting what is not really art," Baudrillard remarked, "unidentified objects I call strange attractors. Actually I saw something at the Israeli Pavilion, characters shaped like spermatology, a kind of monstrous bio. It was inexplicable, beautiful, almost joyous, although kind of tiny. It was a biological theater of cruelty."[7]

At first glance, the installation that followed seemed far more traditional (*In Stone*, 2004), cultural artifacts exhibited in glowing white display-cabinets. It was a display displaying itself to reflect on the idea of a museum, or what confers authority to things. And what was actually being displayed, a few manuscripts, rusty slabs of stone, went a long way to confirm that. Every museum preserves the past to come. It was also a reflection on the status of art in contemporary society. *Looking back* at art not as it conceives itself today, historically for the most part (periodizing time, art history) but anthropologically. Any art is antiquated when looked at from a distance – say, from a bird's-eye-view. What was being exhibited in these glowing vitrines was history itself, or to be more exact what is left of it: *its archaeology*. The history of the human species examined in vitro, as a culture plate. We left *Data Zone* to enter Culture Zone. Actually Rovner was doing to culture as a whole what she had previously done to bodies: stripping culture of all distracting details. The reductive gesture of perceiving it for what it is – phenomenology as art.

Looking at the vitrines up close, suddenly the lines on an open notebook begin to wobble. Closer still, they turn out to be made of microscopic homunculi moving head on, elbow to elbow as if demonstrating publicly together for some cause, it didn't matter what. Would it look like history seen from some huge Hubble telescope in time? The richly textured slabs of stone in other display-cabinets also began imperceptibly to move in turn, teeming with diminutive specks holding hands, or bouncing up and down, walking in a circle or waving at us in spite of their obvious insignificance. They hardly scratched the surface of what for them must be enormous rocks, or continents. Preserving traces of the past? But the past was alive and this video-projection was there to prove it. It was another "living landscape". The immateriality of video-projection as the only rock to hang onto over time.

Next, two big rectangular stones lying down side by side on a sand pit come into view suggesting the desert, or an archaeological dig (*Tablets*, 2004). On their surfaces, two teams of tiny letters are projected, similar in every respect. Are they going to fight over the same territory? No, the two slabs are carefully separated, each a tablet of one's own. They are moving in concert and in view of each other, like two flocks of birds. But the creatures never look at each other, and for a reason: they have no eyes to speak of, hardly a head. They are like little worms dancing on their tiptoes, anonymous ciphers wrapped in the same dark overall. Each crowd moves briskly

in one block, this side, that side, at times simultaneously, often slightly at odds with each other. But their difference in pace or direction is hardly more pronounced than the slight discrepancies that exist between each body. Continuity prevails over differences. The letters keep bending and dipping, as if praying or showing respect. They all seem willing to submit to some external force, God or destiny, as a way of giving some semblance of direction to their lives. We could call it religion. But what is noticeable is the movement. As in *Time Left*, there is no narrative, no beginning or end, just imperceptible repetitions masquerading as progression. It is mesmerizing, like a tetanic reaction. One can't wrench oneself from it. Much better than television.

The letters are definitely not Latin, possibly Hebrew or a mix of Chinese and Aramaic characters, round, oriented to the left. If these were Moses' tablets (but nothing proves that it is) it would go a long way to suggest that Hebrew was originally made to be danced, and the letters purposely anthropomorphized. But the Decalogue proscribed figuration, and the interdiction held until the end of the 10th century. But then, until the Renaissance, Hebrew was extensively turned into animated letters, mostly due to contact with other civilizations. (The figuration of the Latin alphabet started in the 8th century and never stopped after that).[8] More to the point is the fact that *animated letters* (they are often called "letter-people") confirm, in their own way, the reduction of meaning to form

characteristic of Rovner's work. It is this kind of reduction that triggered as well throughout history a prodigious diversity of figurative letters, changing the alphabet into plants and animals, storks, chimps, horses, zebras, unicorns, a rich zoomorphy that rivals in invention the mystagogical values attributed to writing during the Talmudic period, its magical function in the Kabala and in medieval alchemy. Roland Barthes remarked that "letters are used to make words, but alphabets as well." At one point Rovner, thought of making up words with her letters, but abstained. She didn't make an alphabet either. All the letters look alike. Every dancer on the tablets, in fact, is a replication of the same body – Rovner's, actually – but none is a figuration of anything. As Barthes pointed out again: the alphabet is "a syntagm that exists outside of meaning, but not outside of the sign." These tablets give us the empire of the sign, with no meaning attached.

Time Left emphasized the continuity of the human species and the permanence of its structures through the endless procession of multitudes. Rovner's attitude in relation to the human species remains somewhat ambivalent, at once attracted by its resilience, and put off by its inherent conformity. The same ambivalence could also be felt towards the tokens of authority that were displayed throughout *In Stone*; founding texts and tablets, old scrolls that have acquired over time the force of law and the weight of evidence. Behind this order lay a disorder all the more perverse and even ferocious as well as

the inhumanity lurching around what is supposed to be human. Only by multiplying human figures *insanely* and raising the ante did they start loosening up somewhat and enter a world of metamorphosis. What was missing was something untimely and unrestrained, the kind of energy released by the flock of birds, an energy capable of abolishing all borders and connecting to something far more powerful and primordial. When everything is said and done, there is something very pagan in the way Rovner goes about things. She seeks connections and interactions on a cosmic scale, not just among the human species always caught in petty concerns and mindless domestic fights, bloody too, over whatever piece of territory or identity they happen to step into. One can feel her impatience, looking back at it from the point of view of a present that hasn't started yet, maybe never will, and would be the future of humanity. But this present already exists and it can be found in the primal elements humanity keeps being indebted to. If art could only connect to these powerful forces it probably would achieve its goal and reconcile us not only with ourselves – maybe an impossible task – at least with the universe.

This may be at least what Rovner's work is aiming at. Because only the surface has depth. Recently, working on her new piece, *Fields of Fire*, she looked again at a four-part picture she made in 1997 simply titled *Land*, and realized that it was already all there. The fire was the land. Two stretches of khaki-colored desert, one on top of each other, interrupted by a white border that neatly divides the landscape into four parts like a window, or a cross. But this is hardly a framed representation, to the contrary. The flow and the pleating of the land is so powerful that it overrides the white space and resumes undisturbed on the other side. The abrupt separations on the canvas were introduced just for that: to make us realize that whatever attempt we make to stop the thrust of the land, it will deny our efforts and follow its own course, regardless. The landscape is seamless, endless, continuous, just like the wallpaper people, and cannot be interrupted artificially. This is what borders attempt to do, and why they will fail. Nature doesn't have any border, the elements keep flowing into one another. Differences don't make any difference on that count, only those that bring out the profound unity in everything.

Characteristically, *Land* is low-contrast, juxtaposing brown, khaki, sand and earth colors. It is deliberately flat like a Japanese print, but one can feel muscles flexing under the skin and rippling the land. The landscape isn't blurred, actually very precise but dotted throughout, including the sky. It isn't pointillist, because the dots themselves are earth and sand colored, so no optical effect is intended. It may remind us of the cloud of tiny birds cropping around a tree in a striking van Gogh – like a sequence of *Mutual Interest*. Multiplicity of points (or pixels) are what allow us to see, however hard we try to unify the picture. Like the body, or like human faces (but none of Rovner's

creatures have any), the land breathes through all its pores, and energy circulates through it all. There is no difference between interior and exterior, or between ground and sky, it is all one continuous material that can only be affected by changing neighborhoods (topology). It can fold and shrink and stretch differently according to different assemblages, but all obey the same principle: Unity of Composition. And maybe this is what art can do: bring what is perceived as different together in one slow burst of energy. And this doesn't exclude *anything*.

In *Fields of Fire*, Rovner achieved just that, *bringing energy back to its source*: the oil fields. The attention paid worldwide to oil, the escalating prices, the strategic postures of leading nations around the Caspian Sea, certainly had something to do with her choice, the way the crisis in South-Lebanon had something to do with the making of *Border*. But it may be clear by now that she had other reasons to go all the way to Kazakhstan in order to bring back video footage of derricks and flames that she wouldn't use. You have to start in one reality before shifting to another. It took Rovner some time to come back to what she knew she would do from the start: explore a situation, not a narrative; use repetition; work from one element, but turning it into many things. These were the very principles she used for *Time Left*. More surprising was that instead of using statistical repetitions (the crowd is a statistical phenomenon) and reducing the scale of the human material accordingly, she would once again do the unexpected: blow the flame up 10 meters high. Like *Time Left*, the procession stopped being a simple fresco, something you look at, and became an environment (something that *looks at you*). In *Fields of Fire*, it goes even further and engulfs everything like the fire of God.

This could be a political response, or a fanatical reaction, to an issue that is enflaming passions and fueling corporate greed (and massacres) on a world scale. But it was not primarily what Rovner had in mind. In *Fields of Fire*, her own challenge was to make a painting with fire. Yves Klein had already done that once, but literally, using a blow torch as a brush and applying it to a canvas with a fireman by his side. Rovner paints with a video. But it is a painting that she is doing, *a still life that moves*, a fluid landscape that keeps swallowing itself and recreating itself constantly, impossible to grasp because it never stops moving and changing. Phoenix without the ashes.

Instead of being vertical, the flame is horizontal, like a landscape of fire, a flowing fresco, a moving text. But fluid like water and the air, all manifestations of the same thing, all issued from the land. But with an urgency that the others may not have had to the same degree: the urgency of combustion, the speed of particles burning and blowing out.

Like *Data Zone*, it is an experiment with the material, not just its exploitation. Rovner took the outer edges of the flame, and not the flame itself, so the two edges would flow concurrently, sometimes joining, other times creating between them

gaps and figures in constant metamorphosis. Once again, we are thrown into the in-between, in the porous borders of the fire. Finally Rovner managed to make of fire a borderline phenomenon. Artificially divided in *Land*, it is finally returned to its natural flow in the *Fields of Fire*.

Coda

Some fifteen years ago in New York I arranged to have a reading of French writer Pierre Guyotat videotaped. Guyotat asked the cameraman to shoot closer, and the man shot his lips, reading. "No," insisted the writer, "you should shoot here." And he pointed to his throat.

Discussing with Michal Rovner the various postures the silhouettes adopt in her work, I pointed out to her that isolated individuals often look down, as if burdened by guilt, but not the people who hold hands. Rovner looked at me with incredulity and said: "But they are not looking down, they're looking at the ground."

Sylvère Lotringer

Thanks to Laura Baird for copy-editing this text.

1 Jean Dykstra, "Michal Rovner: Crossing Borders," *Art on paper*, September-October 2002.

2 Hervé Le Guyader, *Geoffroy Saint-Hilaire : un naturaliste visionnaire*. Paris: Belin, 1998. In 1820, Geoffroy Saint-Hilaire invented "transformism."

3 *Mutual Interest*, 1997; *Descent*, 1998; *Untitled*, 1998; *Crosses*, 1999; *Echo*, 1999, etc.

4 *Merging* and *Merging in the Wind*, 1997; *Blur*, 1998; *Adama* (Earth) and *Pull*, 1999.

5 Elias Canetti, *Crowds and Power*. New York: Farrar, Straus and Giroux, 1960.

6 René Thom, *Prédire n'est pas expliquer*. Paris: Éditions Flammarion, 1991. The notion of attractors was developed in the context of chaos theory. An attractor has a fractal structure and undergoes constant change, although its global attraction remains the same.

7 Jean Baudrillard / Sylvère Lotringer, "Too Much is Too Much," in *The Conspiracy of Art*. New York: Semiotext(e), 2005.

8 René Massin, *La Lettre et l'Image*. Paris: Éditions Gallimard, 1970.

PEOPLE WALKING – WHERE ARE THEY GOING?

Every second the people stream together and go apart,
they approach each other to get closer to one another.
They unceasingly form and reform compositions in unbelievable complexity…
It's the totality of this life that I want to reproduce in everything I do.[1]

Alberto Giacometti

In recent years the spaces of Michal Rovner's work are populated by people in motion, as individuals, or as groups the causes for whose congregating together remain enigmatic. The experience of human movement in her works engraves itself deep in our memories, as though we have walked a long way with these moving people on a shared route whose meaning reflects upon our own lives as well. Rovner's figures move with a tireless compulsiveness, as if stubbornly intent to continue conducting the journey again and again before our eyes: long rows of walkers enter into the bounds of the format (be it paper, canvas, the frame of the film or of the video) and exit from it, while the movement in and out raises questions about order and disorder; groupings of people gather together and disperse in the tempo of a spectacular revue, which requires a firm infrastructure of organization and power mechanisms – but their contortions attest to their struggle to survive inside these mechanisms. The more transparent these walkers become, the more the trails of their footsteps accumulate as a presence that is well known to us.

In *Time Left* (2002), which is screened in a dark room, we see rows upon rows of people walking. They walk *en masse* from wall to wall, and as-it-were return on their tracks each time they complete the journey around the four walls that enclose the space of the room. The image of the people moving

at a dizzying pace and in an endless loop hypnotizes the viewers. The viewers' entries into and exits out of the space have no influence whatsoever on the journey of these figures, who move by dint of an unknown compulsive force, that also sweeps the viewers along to twist and turn around themselves, watching the processions passing before their eyes. The rows of walking people, which fill the walls of the gallery from floor to ceiling, encompass the viewer in a great mass of movement that has neither beginning nor end. The distance from which the figures were shot has blurred their social or ethnic identity and erased the environmental traits of the place of the occurrence – but tiny hints preserved in these silhouettes, which have been reduced and are dissociated from any environment, still enable us to distinguish some distinctiveness of age, gender, perhaps even lines of character.

The presentation of the journey of the figures in horizontal strips running one above the other along the four walls of the room does not permit a continuous reading of what is happening. The viewers, who move in the space in a random manner, are not given a narrative hanger that could make it possible to combine the various parts of the scene into a cohesive continuum. The sense of frustration and missing out that arises in the viewers, who are required to encompass an occurrence that keeps moving out of their field of vision, is intensified as a consequence of the multiplicity of contexts and possibilities of interpretation that the work offers without committing itself to

any one of them. Who are these people? Where are they going and what is the force that motivates them? But the more the viewers are swept into the repetitive rhythm of the movement, the less need is felt for hints that combine into a coherent narrative, and the attention shifts to self-observation, to each person's private journey, to reflections on the limitations of human experience and understanding.

In the work *Data Zone* (2003) we see 15 circular units that look like Petrie bowls, and what is going on in them brings to mind processes of proliferation and decay, building and destruction, life and death. The view from above of the people moving, entering into and exiting from the circular boundaries of the bowls, distances Rovner's contemplation of man and his movements one stage further – from the social dimension to the biological dimension. For a moment one is reminded of works by Damien Hirst, like the dead butterflies in the round glass frames – but while Hirst touches on death in order to discuss love-hate feelings towards the exhibit ("You need to find universal triggers, everyone's frightened of glass, everyone's frightened of sharks, everyone loves butterflies"[2]), Rovner's laboratory specimens present a process that does not seek to tempt the viewer to either positive or negative responses.

In Rovner's work, too, the moving frames of the strip of celluloid or video focus the attention on the stages of metamorphosis or transition (which are emphasized by means of cut-

ting of one kind or another, by means of slowing or acceleration of the movement), while the stills photographs isolate the moment of metamorphosis out of the duration of the occurrence (this isolation is emphasized even more by means of the individual treatment of each photograph). But Rovner's discussion of movement is closer to the way Marcel Duchamp presents it in paintings such as *Nude Descending a Staircase I* (1911), or *Sad Young Man in a Train* (1911-12): in these paintings, the human body and its movement do not represent what is visible, but the mental state, for in those years, as he later told Pierre Cabanne, Duchamp was interested in "turning inward, rather than toward externals".[3]

In order to interpret the incomprehensible coupling of conceptuality and images of memory in the works of Michal Rovner,[4] John Hanhardt drew upon the following lines from Paul Celan's poem "The Straitening":[5]

"Driven into the
terrain
with the unmistakable track:
[…]
Do not read any more – look!
Do not look any more – go!"

The poem's title in the original German, *Engführung*, comes from musical terminology, and denotes a maximal contrapuntal compression, to the point almost of simultaneity, of the voices of a fugue towards its conclusion. The congregating of the walking people in Rovner's works, too, is orchestrated, and their walking also sweeps the viewers along, who sooner or later find themselves walking among them, to regions that Rovner refuses to call by name or to reveal anything about their identity. The code for interpreting the space her figures operate in is contained deep in the viewers' memories, and only their being swept along to the unknown that is in the text makes it possible, at a moment of grace, to transpose the place and the time from the unconscious to the conscious. Not so in the poem by Celan, for whom existence and the void are bound up in the trauma of the Holocaust. Shimon Sandbank, who translated the poem into Hebrew, proposes Peter Szondi's interpretation: "The reader-speaker is led to a terrain that may be seen as a landscape of death, probably of an extermination camp, or as a written text: its white stones are tombs and also a blank page, the shadows of its leaves are the shadow of death and also letters, and scattered dust is written in. A text such as this, which is one with the reality embodied in it, invites not reading but looking, and not looking but going about within it. This going is the going of memory that returns to the hour of death, and only through his remembering of death, the moment that is unlike any other, can man 'be there'. What does not allow one to look and to remember is something that is flung among the dead and is impossible to see through – perhaps sleep, perhaps the unconscious.

Time ticks to them, seeks to awaken them, the finger gropes beyond the years and examines the open or mended scars, in an attempt to remember, to arrive at the redeeming word, at a speech that will not be merely speech 'about words' but real speech, or, since the text and the reality are identical – real existence".[6]

Rovner refuses to connect her works with the Holocaust, but (as in Celan's writing) the past and the dangers of the present cohere in them inseparably, for – as Stefan Moses, inspired by Walter Benjamin, wrote about Celan – "to express the past historically" is "to hold on to the memory that flashes at a moment of danger". This dimension of historicity, Moses adds, "reveals itself beyond the separation between external history and internal history and exposes the fateful unity of existence and world".[7]

After the video installations that Rovner presented at the Stedelijk Museum in Amsterdam and the Whitney Museum in New York, critics already spoke of the breakthrough entailed in the breaking of the format of the video screen into the architectural space and in the expansion of the images to monumental proportions. But the innovation in these installations lies not only in the technological achievement but also in their success in conveying simultaneously the dimension of time (by means of a concrete continuum of images of movement) and a sense of timelessness (by means of distancing the images to the atmosphere of the viewer). This distinctive assimilation of time in the display space identifies Rovner's language and differentiates her from other video artists who remain faithful to the basic format of the medium. Her work has not infrequently been compared to that of Shirin Neshat, but what separates the two is not only a contextual abyss (Neshat's political articulation is direct and outspoken), but principally the different uses they make of the video language.

In the work *Data Zone*, the frames of the images receive the circular form of Petrie bowls – and these invite a close regard like that of a researcher examining the object of his research, which entirely changes the conventional way of looking at the screen (the work with these culture surfaces crystallized after a long research study that Rovner conducted at the biotechnological laboratories at the Weizman Institute of Science). Except that the figures of the researchers have been photographed in a view from above, as though observed from outer space and caught as human animals whose movements stem from some unclear logic. The distanced regard of the researchers' focused regard situates human science in a new perspective, which does not rule out as impossible a loss of control and a bursting of the boundaries of ethics like a Pandora's box – whether in the domain of genetic engineering, or in other domains of politics, society and culture. Rovner's bi-focal regard turns into a hard metaphor on the human interaction that characterizes our times.

Rovner's way of treating the actuality that is registered by the camera lens is closer to painting and to sculpture than to photography. She re-photographs the photographed object over and over again after treatment – technological in the laboratory, and manual – to create an actuality that is metaphorical only. This "erasure of data" continues the path of Giacometti, who complained that he had not erased enough. The initial negative, in this process, becomes a kind of drawing, in which only the traces of its subject remain, while it itself has vanished, as irrelevant information. It appears that Rovner is interested not in what is visible in her negatives, but in what is hidden in them, and it is this that she seeks to bring to light.

In *Wall Text* (2003), a work created especially for the exterior wall of the Israeli Pavilion at the Venice Biennale, we see the same figures that also appear in *Time Left* – groups of people in their fifties, whom Rovner directed and photographed in Russia and Rumania. The photographs underwent various treatment processes until they were abstracted into something like codes of a language. Materials that were shot on video became stills photographs that were used in a print which became a wall-painting, one that brings to mind the traces of life that were preserved on the walls of Pompeii or the graffiti scribbles that today cover the walls of cities. The technical reproduction, with its various transformations, restores to the digital immateriality of the video a presence of large sheets of printed paper or canvas (the screens for the wall prints of the work were prepared at the print workshop of Har-El Printers and Publishers in Yafo) that preserve traces by means of touch.

Mordechai Omer

1 Alberto Giacometti, "Ma longue marche", *Écrits*, eds. Michel Leiris and Jacques Dupin. Paris: Hermann, 1990.

2 Damien Hirst, *I want to spend the rest of my life everywhere, with everyone, one to one, always, forever, now*, ed. Robert Violette. New York: Monacelli, 1997, p. 132.

3 Pierre Cabanne, *Dialogues with Marcel Duchamp*. London: Viking Press, 1979, p. 19.

4 John G. Hanhardt, "Inside the Surface: The Art of Michal Rovner", in *Michal Rovner*, exhibition catalogue. New York: The Bohen Foundation, 1996.

5 Paul Celan, "The Straitening", *The Poems of Paul Celan*, translated by Michael Hamburger. New York: Persea Books, 1972, p. 115.

6 Shimon Sandbank, "Notes on the Poems and the Prose", *Paul Celan: Selected Poems and Prose* [in Hebrew], selected, translated and annotated by Shimon Sandbank. Tel-Aviv: Siman Kriah Books, Hakibbutz Hameuchad Publishing House, 1994, pp. 37-44.

7 Stefan Moses, "To Hold On To The Memory That Flashes At a Moment of Danger" [in Hebrew], *Hame'orer* 3, Spring 1998, pp. 48-49.

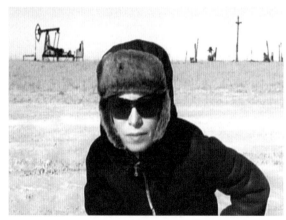

MICHAL ROVNER'S *FIELDS OF FIRE*

Michal Rovner's quests for and engagements with charged sites, such as the Dead Sea (1993-94), or the environs of Moscow (2001), stand as-it-were in contrast with her compulsive need to distance herself and almost to erase most of the environmental features among which she chooses to situate her cameras. In the autumn of 2004 she sought once again to experience landscapes and energies that had so far been foreign to her and distant from her, and thus she arrived in Kazakhstan. The focus of her interest was to become acquainted with the process of sucking oil from the bowels of the earth, to contemplate the oil fields with their machines drilling ceaselessly, and the flames of fire around the jets of gas that burst through in the course of penetration into the layers that signal the presence of the lakes of oil beneath them. The sight of the flames of burning gas rising from the infinite and desolate expanse of the surface of the oil fields fascinated the artist.

The further she distanced herself from the place itself and the deeper she delved into the materials she had brought with her from Kazakhstan, it seems that the story of the oil fields came to lose its original meaning. Her memory of the place is connected with a reverence for the powers of nature, for a life environment that never ceases changing, that is concealed from our eyes, yet its existence is known well

within us. This "emptiness full of life" that may be discovered in these primordial landscapes has been well described by the author Paulo Coelho in his book *The Zahir*, which also emerges from the landscapes of Kazakhstan: "I saw the endless steppes, which although they appeared to be nothing but desert, were in fact, full of life, full of creatures hidden in the low scrub. I saw the flat horizon, the vast empty space, heard the sound of horses' hooves, the quiet wind, and then, all around us, nothing, absolutely nothing. It was as if the world had chosen this place to display, at once, its vastness, simplicity and complexity. It was as if we could – and should – become like the steppes, empty, infinite, and, at the same time, full of life."[1]

More than anything, in her visit to Kazakhstan Michal Rovner sought not this country's emptied and pastoral landscapes, but to arrive at the primary and natural sources of the "black gold", to be together with the earth that has been exploited and appropriated by the powers which, by means of their political, economic and military strength, channel the sources of energy in the world as a commodity that is under their control. The difficult crises and shocks the world is undergoing in the course of and because of the marketing of oil has turned this commodity into a focal and a powerful resource which is produced from the exploitation of natural sources, not always for purposes that have been of benefit to mankind. The aim of the visit to "the scene of the crime" was

to create some sort of correlation between man and certain movements in the geo-political region and in the historical time.

In the first stage Michal Rovner focused on an individual flame, in order to characterize and reinforce the bounding line. The further she advanced in the reductive process, the contour revealed itself as a basic component that makes it possible to define and to characterize the form from which the flame is built. At a more advanced stage the vertical structure became horizontal, producing a narrative of abstract sights in motion, like fleeting landscape sights that reveal themselves during a rapid journey which has neither beginning nor end. The surface became brighter and brighter, more and more transparent, as though built of skilled rapid brushstrokes of a calligraphy that stems from the spirit of the tradition of the Far East. From a different viewpoint one could see a seismographic drawing that follows geological strata or a flow of lava pouring heavily from the maw of an erupting volcano.

The laying-out of the work along the elongated frame does not allow the viewer to register the full length of the journey of flowing lines in one gaze, and the eye in fact has to follow in the wake of the flow of lines and be captivated by the trails of their burning. For a moment we return to the large formats of the action painters of the New York School and to the eye captured in the tremor of the quivering strings of Barnett Newman's "zips" or of Mark Rothko's floating squares. And while

speaking of how Michal Rovner wants to capture the rhythm of the flames of the fire, it is impossible not to recall Jackson Pollock's fascinating early painting *The Flame* (1934-38), which is in the collection of the Museum of Modern Art in New York. In a monograph on Jackson Pollock, Ellen G. Landau writes: "Although vestigial imagery remains in *The Flame*… the powerful emphasis on flickering lights and darks and interlocking twisted shapes all but obscures the ostensible subject".[2]

Like Pollock, Michal Rovner too, in her series of works on the "Fields of Fire", employs the power of the *figura serpentinata*, which is associated with the "spiral dynamics" of Mannerism (the flame of the candle was one of the most important paradigms of this spiral line). To the same extent, however, she subverts this logic, and turns the set of windings of the flame into a radical and uncompromising deconstruction.

The matrix that Michal Rovner weaves from the flames of the fire oscillates between the convergence of the motion of the flames into a soft, containing, womb-like, feminine flow, and the upwardly jutting eruptions that contradict and injure this move, like a tsunami wave that scatters and destroys everything in its path.

Surprisingly, one can see the journey of the horizontal flames of fire as a struggle between a passivity of flow that keeps faith with the rhythms of its burnings, and eruptions that deviate from the continuum of the ordered lines, while dismantling them into flarings and fadings that break the order which for a moment had seemed to have found a balance. In many senses the vector of the forces and the energies of the burning evokes something from Jacques Derrida's fascinating remarks to Elisabeth Roudinesco on the question of his loyalty to the heritage of life and creation and his criticism of it: "True, I have always, be it in relation to life or to the work of the mind, recognized myself in the figure of the heir – and more and more, as a role I have assumed, often happily. When explaining myself insistently with this concept or this figure of the legatee, I have come to think that far from an assured comfort that one associates a little too quickly with this word, the heir has always to respond to a sort of double injunction, a contradictory assignment: one must first of all know, and know how to *reaffirm*, that which comes 'before us', and which we therefore receive without even choosing it, or being able to comport ourselves with respect to it as free subjects. Yes, one *must* (and this *must* is inscribed in the very heritage received), one must do everything in order to appropriate for oneself a past that one knows remains at bottom inappropriable, whether it has to do with philosophical memory, with the precedence of a language, of a culture, or with filiation in general. To reaffirm– what does that mean? Not only to accept it, this heritage, but to restart it differently and to keep it alive. Not to choose it (for what characterizes a heritage is

first of all that one does not choose it, it is it that elects us, violently), but to choose to keep it alive. Life, at bottom, being alive – this defines itself, perhaps, by this internal tension of the heritage, by this reinterpretation of what is given in the gift, and, indeed, of one's filiation. This reinterpretation, which simultaneously continues and interrupts, resembles, at least, an election, a selection, a decision. One's own like that of the other: signature against signature. But I will not use any one of these words without surrounding them with quotation marks and cautions. To begin with, the word 'life'. We will have to think of life by starting from the heritage, not the inverse. We will therefore have to start from this apparent and formal contradiction between the passivity of the reception and the decision to say 'yes', and then to select, to filter, to interpret, and therefore to transform, to not leave intact, undamaged, to not leave *safe* even that which we wish to respect before everything. And after everything. To not leave safe; to save, perhaps, again, for some time, but without any illusion of a final salvation."[3]

The distance from which Michal Rovner views the flames of fire hints at some mighty need to see them as perpetually unified through the subjugating power of some "eternal return" that refuses to die out. But at the same time she subverts that unifying flow and returns to those outlines of the flame of fire and gives herself to that other "injunction" that Derrida emphasizes, "in order to save life (in its finite time) –

to reinterpret, to criticize, to displace, that is to say to intervene actively so that a transformation worthy of its name can take place: so that something will occur: an event, of history, of the unforeseeable to-come."[4]

Michal Rovner isolated a single flame of fire and observed it in the course of its process of transformation in time and place. Concurrently, she added the traces of the smoke emitted from the burning of the flame, which at times rises above the flame, and erases the bounds of its existence, while at times the flame bursts through its pillars of smoke and flares up in an even greater burning. From a distance the layers of fire look like an expanse floating in the air, upon which are drawn curves made by a seismograph that follows and documents an energy which is activated from within its own innermost powers, without our having any ability to understand the meaning of the phenomenon and the laws of cause and effect that dictate its behavior.

The power and the meaning of fire were a subject of Gaston Bachelard's exciting research in his book *The Psychoanalysis of Fire*. His conclusion, that dream is stronger than any experience, makes it possible to also explain the point of departure and the series of works that Michal Rovner has created after the burnings in the oil fields of Kazakhstan: "It can be seen that in the most varied circumstances the call of the funeral pyre remains a fundamental poetic theme. It no longer corresponds in modern life to any real-life observation. It does

stir our emotions nonetheless. From Victor Hugo to Henri de Régnier, the funeral pyre of Hercules continues, like a natural symbol, to portray to us the destiny of mankind. That which is purely artificial insofar as objective knowledge is concerned remains then profoundly real and active for unconscious reveries. The dream is stronger than experience."[5]

Mordechai Omer

1 Paulo Coelho, *The Zahir*, translated from the Portuguese by Margaret Jull Costa. New York: Harper Collins Publishers, 2005, p. 313.

2 Ellen. G. Landau, *Jackson Pollock*. New York, 1989, p. 36.

3 Jacques Derrida and Élisabeth Roudinesco, *De quoi demain… Dialogue*. Paris: Fayard/Galilée, pp. 15-16; excerpt translated from the French for this article by R. F.

4 *Ibidem*, p. 16.

5 Gaston Bachelard, *The Psychoanalysis of Fire*, translated from the French by Alan C. M. Ross. London: Routledge & Kegan Paul, 1964, p. 20.

JEU DE PAUME EXHIBITION – LIST OF WORKS

MICHAL ROVNER

Born 1957 in Israel and since 1988 has a studio in New York City

One-Person Exhibitions

2005 Jeu de Paume, "Fields," Paris, France. Co-produced by Festival d'Automne à Paris
Gow Langsford Gallery, "Michal Rovner," Auckland, New Zealand

2004 PaceWildenstein Gallery, "In Stone," New York, NY 2003
Venice Biennale, "Against Order? Against Disorder?" One-person installation for the Israel Pavilion, 50th International Art Exhibition, Venicc
MACRO, Museo d'arte contemporanea Roma (Al Mattatoio), "Arena." Concurrent with solo exhibition, "Coexistence," at Studio Stefania Miscetti, Rome

2002 Whitney Museum of American Art, "Michal Rovner: The Space Between." Mid-career Retrospective, New York, NY
Stephen Friedman Gallery, London

2001 Baldwin Gallery, "Michal Rovner: New Work," Aspen, CO
Kemper Museum of Contemporary Art, "Michal Rovner: Works," Kansas City, MO
Shoshana Wayne Gallery, Santa Monica, CA

2000 New Gallery, "Michal Rovner: Between," Houston, TX
Stephen Wirtz Gallery, "Michal Rovner: New Works," San Francisco, CA

1998 Rhona Hoffman Gallery, "Michal Rovner: Recent Work," Chicago, IL
Stephen Friedman Gallery, London
Studio Stefania Miscetti, "Michal Rovner: Recall Seeing," Rome
New Gallery, "Border," Houston, TX
The Schmidt Center Gallery, Florida Atlantic University, "Michal Rovner: Selected Works, 1991-1998," Boca Raton, FL

1997 Tate Gallery, "Michal Rovner: Art Now 10," London
Pace Wildenstein MacGill, "Michal Rovner: Photographic Works," New York, NY
Shoshana Wayne Gallery, Santa Monica, CA
Stephen Wirtz Gallery, San Francisco, CA

1996 The Bohen Foundation, "Michal Rovner: Works, 1991-1995," New York, NY

1994 "Michal Rovner", Laura Carpenter Fine Arts, Santa Fe, New Mexico

1993-1994 Michal Rovner, The Art Institute of Chicago, Illinois

Site Specific Video Installations

2005 Chanel Headquarters, Hong Kong. Peter Marino Architects
"Living Landscape" at Yad Vashem, The Holocaust Martyr's and Heroes' Remembrance Authority, Jerusalem. A permanent twelve meter high video wall

2004 LVMH Headquarters, "Untitled Paris 2003," Paris

2000 "Overhang," Outdoor night installation projected through
 17 windows to the street. Deitch Projects, Chase Manhattan Bank,
 New York, NY

1999 "Overhanging", New Wing Ground Floor, approximately 500 sq.
 meters/5382 sq. feet, video installation. Day indoor version: two
 walls facing each other projected on 18 windows to create one
 situation. Nighttime outdoor version: projection through 9 windows
 to the street, approximately 40 meters/131 feet long, Stedelijk
 Museum, Amsterdam

Video Installations / Projections

2001 Ackland Art Museum, The University of North Carolina, "Field 1,"
 Chapel Hill, NC

2000 Corcoran Gallery of Art, "Coexistence 2," as part of "Media/
 Metaphor: The Forty-sixth Biennial Exhibition," Washington, DC
 Whitney Museum of American Art, "Field 1," as part of "2000
 Biennial Exhibition," New York, NY

1999 P.S. 1, "Mutual Interest," as part of "Animal. Anima. Animus," New
 York, NY

1997 Stedelijk Museum, "Mutual Interest," as part of "World Wide Video
 Festival," Amsterdam
 Tate Gallery, "Mutual Interest," London

Film Screenings

• Film/Video: Notes, Collaboration with composer Philip Glass, 11 min.
 Premiere Screenings: Lincoln Center Festival, New York, NY, as part of
 "Shorts," 2001, Barbican Theater, London, as part of "Shorts," 2003
• Film: Border, Shot on the border between Israel and Lebanon. A fictional
 story made from documentary footage, 50 min.

Premiere Screening: Museum of Modern Art, New York, NY, 1997
Screenings: Tate Gallery, London, 1997; Stedelijk Museum, Amsterdam,
1997; Los Angeles County Museum of Art, Los Angeles, CA, 1997;
MacArthur Foundation, Chicago, IL, 1998; Palazzo delle Esposizioni,
Rome, 1998; Museum of Fine Arts, Houston, TX, 1998; The Fabric
Workshop and Museum, Philadelphia, PA, 2000; Tel Aviv Cinematheque,
Tel Aviv, 2000; The Israel Museum, Jerusalem, 2000; Museo Nacional
Centro de Arte Reina Sofia, Madrid, 2000; Corcoran Gallery of Art,
Washington, DC, 2001; Whitney Museum of American Art, New York, NY,
2002; Museum of Contemporary Art, Chicago, IL, 2003; Tate Gallery,
London, 2004

Selected Group Exhibitions

2005 Moscow Biennale of Contemporary Art, "The Dialectics of Hope,"
 Moscow
 Centro Cultural Conde Duque, MediaLab Madrid, "banquest_05
 communication in evolution," Madrid
 Regina Miller Gouger Gallery, "Groundworks" – Environmental
 Collaboration in Contemporary Art, Pittsburgh
 PaceWildenstein, "Logical Conclusions: 40 Years of Rule Based Art,"
 New York, New York

2004 Charlottenborg Exhibition Hall, "Dwellan-Lingering Images exhibi-
 tion of contemporary video art," Copenhagen
 Shanghai Biennale, "Techniques of the Visible," Shanghai

2003 Bowdoin College Museum of Art, "The Disembodied Spirit,"
 Brunswick, ME
 PhotoEspaña, "NosOtros. Identidad y alteridad," Madrid
 UCR/California Museum of Photography, "One Ground," Riverside,
 CA
 Museum of Contemporary Art, "War (What is it Good For?)"
 Chicago, IL

2002 Westport Arts Center, "The Endurance of Art," Westport, CT

2001 Harley Baldwin Gallery, Aspen, CO

2000 Tel Aviv Museum of Art, "Exposure: Recent Acquisitions, The Doron
 Sebbag Art Collection, O.R.S. Ltd.," Tel Aviv
 Stephen Friedman Gallery, "Drawing," London
 Applied Materials, Applied Global University, "Looking Ahead:
 Visions of Israel," Santa Clara, CA. Traveled to the San Jose Institute
 of Contemporary Art, San Jose, CA

1999 Whitney Museum of American Art at Champion, "Zero-G: When
 Gravity Becomes Form," Stamford, CT
 Museum of Contemporary Art, "Apposite Opposites: Photography
 from the MCA Collection," Chicago, IL

1998 Poori Art Museum, "Animal. Anima. Animus," Poori, Finland. Traveled
 to Museum voor Moderne Kunst, Arnhem, Holland, 1998-99; P.S. 1,
 New York, NY, 1999; and Winnipeg Art Gallery, Winnipeg, Canada,
 2000

1997 Dazibao, Centre de photographies actuelles, "De la minceur de
 l'image / The Tenuous Image," Montreal, Canada
 New Gallery, "The Thom Conjecture: Michal Rovner, Fran Siegal,
 Sharon Horvath, Moshe Gershuni," Houston, TX

Selected Public Collections

The Metropolitan Museum of Art, New York, NY
Museum of Modern Art, New York, NY
The Whitney Museum of American Art, New York, NY
The Guggenheim Museum, New York, NY
The Art Institute of Chicago, Chicago, IL
Museum of Contemporary Art, Chicago, IL
Los Angeles County Museum of Art, Los Angeles, CA
San Francisco Museum of Modern Art, San Francisco, CA
Museum of Fine Arts, Houston, TX
The Corcoran Gallery of Art, Washington, DC
Fine Art Museum, Santa Fe, NM
The Jewish Museum, New York, NY
Indianapolis Museum of Art, Indianapolis, IN
The Brooklyn Museum, Brooklyn, NY
Paris Audiovisuel, Paris (Collection de la Ville de Paris)
Bibliothèque Nationale, Paris
Museo d'arte contemporanea Roma (Al Mattatoio), Rome
Musee de l'Elysee, Lausanne, Switzerland
International Museum of Photography at the George Eastman House,
Rochester, NY
The Israel Museum, Jerusalem
The Tel Aviv Museum, Tel Aviv
Yad Vashem Holocaust Memorial Authority, Jerusalem
Polaroid Collection, Boston, MA
Bohen Foundation, New York, NY
Reader's Digest Collection, New York, NY
Agfa Collection
Lambert Art Collection, Geneva, Switzerland
Duma Lutie, Brussels, Belgium
Musée des Beaux Arts, Calais, France
Phoenix Art Museum, Phoenix, Arizona

This book is published on the occasion of Michal Rovner's exhibition, *Fields*, organized by the Jeu de Paume in Paris, in partnership with the Tel Aviv Museum of Art, and curated by Régis Durand and Véronique Dabin, with the assistance of Edwige Baron.

Jeu de Paume, Paris: October 4 – December 31, 2005

Tel Aviv Museum of Art, Tel Aviv: March – May, 2006

As part of this exhibition, the installation *Fields of Fire* has been conceived by Michal Rovner in collaboration with Heiner Goebbels for the sound part, and coproduced by the Jeu de Paume, the Festival d'Automne in Paris and PaceWildenstein, New York.

ACKNOWLEDGMENTS

Our warmest thanks to Michal Rovner for her commitment to both exhibition and book, as well as to her assistants: Avi Mussel, Dikla Ben Atia and Vanessa Fogel.

We express our gratitude to Heiner Goebbels, as well as to the Festival d'Automne in Paris, its General Director Alain Crombecque, and Josephine Markovits, Music Program Director.

This exhibition would not have been possible without the support of PaceWildenstein, New York. Many thanks to Andrea and Marc Glimcher, as well as to Elizabeth Sullivan.

We are also very grateful to the lenders:

Booth Family

Andrea and Marc Glimcher, New York

Ovitz Family, Los Angeles

Heather and Tony Podesta, Falls Church, Virginia, U.S.A.

as well as those who prefer to remain anonymous.

MICHAL ROVNER WISHES TO THANK:

Many thanks to Régis Durand, Director of the Jeu de paume and to Véronique Dabin, Head of the Exhibition Department at the Jeu de paume. Many thanks to team of Festival d'Automne and especially to Alain Crombecque General Director and to Josephine Markovits Program Director of Festival d'Automne for initiating the collaboration with Heiner Goebbels. Thanks to Heiner for his wonderful sound. Thanks to Gerhard Steidl for his high standards.

Thanks to Régis Durand, Professor Mordechai Omer, and Professor Sylvere Lotringer for their insightful texts.

For making it possible for me to film in the oil fields of Kazakhstan, I would like to thank Moshe Ziv, the Alaton family and Alarko Holding A.S., and Matin Oil.

Many many thanks to my devoted team: Danny Itzhaki—editor, Avi Mussel—production supervisor and editing Dan Tomer—digital compositing, Dikla Ben Atia—production coordinator, Michele Fliegler, Vanessa Fogel—studio manager, Rami Hovev and Zohar Goren—studio assistants. Thanks to the additional crew of *In Stone* and *Data Zone*: Ronen Shaharabani—editing, Aharon Peer—production and technical support, Ilya Shargorodski—sound of *Tablets*. My thanks also to Yael Lotan, Ben Schwartz, and Rita Zohar.

Many thanks to Elizabeth Sullivan and the entire staff of PaceWildenstein.

Many thanks to Marc and Andrea Glimcher for all their support and for a great dialogue and to Arne and Milly Glimcher.

Thanks to Martin Weyl, The Beracha Foundation, Gravity, Shoshana Wayne, Nira and Shlomo Nehama, Oded Halaf, Aviv and Feri Giladi.

Special thanks to Yad Vashem.

With love to my parents, Jack and Ruth Rovner and to Tomas for understanding.

With the support of LVMH / Moët Hennessy . Louis Vuitton

Neuflize Vie supports the Jeu de paume

Neuflize Vie
ABN AMRO

First edition 2005

Book design: Michal Rovner, Gerhard Steidl and Claas Möller

Scans done at Steidl's digital darkroom

Printing: Steidl, Göttingen

STEIDL

Düstere Str. 4 / D–37073 Göttingen

Phone +49 551-49 60 60 / Fax +49 551-49 60 649

E-mail: mail@steidl.de / www.steidl.de / www.steidlville.com

ISBN 3-86521-216-6

ISBN 13 978-3-86521-216-0

Printed in Germany